INDIANA

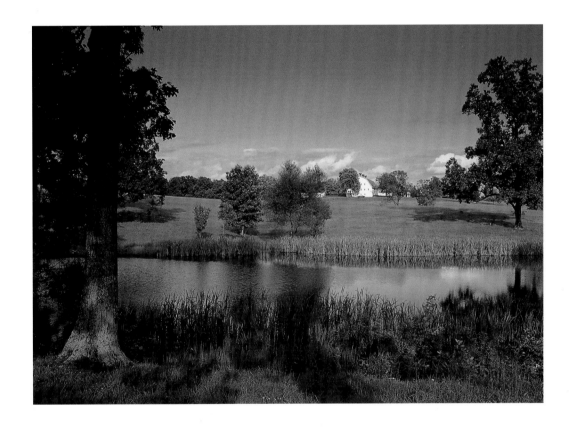

WHITECAP BOOKS

Text by Tanya Lloyd Kyi
Edited by Elaine Jones
Photo editing by Tanya Lloyd Kyi
Proofread by Lisa Collins
Cover layout by Jacqui Thomas
Interior layout by Jane Lightle

Printed and bound in Canada

National Library of Canada Cataloguing in Publication Data

Kyi, Tanya Lloyd, 1973–
 Indiana

 (America series)
 ISBN 1-55285-358-6

 1. Indiana—Pictorial works. I. Title. II. Series: Kyi, Tanya Lloyd, 1973-
America series.
F527.K94 2002 977.2'044'0222 C2002-910204-7

The publisher acknowledges the support of the Canada Council and the Cultural Services Branch of the Government of British Columbia in making this publication possible. We acknowledge the financial support of the Government of Canada through the Book Publishing Industry Development Program for our publishing activities.

For more information on the America Series and other Whitecap Books titles, please visit our web site at www.whitecap.ca.

For those exploring the sights of Indiana—hiking the scenic banks of the Ohio River, negotiating the heart of downtown Indianapolis, or sunning on the sand dunes of the Lake Michigan shoreline—the state gives a warm Hoosier welcome. What exactly is a Hoosier? Not even the locals are sure.

A worker in the corn fields of northern Indiana, framed against the silhouette of a round barn or a restored covered bridge, might say that hoosier is a French word, referring to the residents of the countryside, or an English word for someone of the hills. A hiker in the wilderness of Hoosier National Forest in the south might mention the name of Samuel Hoosier, a Kentucky canal builder who hired dedicated Indiana workers and called them Hoosier's men. Of course, the existence of Samuel Hoosier is unproven. Yet another Indiana resident, perhaps one from the busy streets of Fort Wayne or Bloomington, might say the word stems from a curious and friendly nature, from the early settlers' habit of calling "who's here?" as they passed a house or as they heard visitors at their doors.

Whatever the origin, the nickname carries a tradition of hospitality—one thing the entire state holds in common. The rest of Indiana is a celebration of diversity. To balance the twenty-first-century glass and steel skyscrapers of Indianapolis, there are the fossil beds of 500 million years ago waiting on the edge of the Ohio River. The historic buildings that marked the attempt to achieve utopia in New Harmony stand in counterpoint to the monuments and modern architecture that decorate Columbus. And the railroads and highways that are the transportation network of Indiana's thriving industries run along the fencelines of third-generation family farms.

For the visitor exploring these regions for the first time or the resident rediscovering the reaches of the state, there are thousands of galleries and museums, forests and parks, waiting to be revealed. And at each there are Hoosiers ready to offer a warm Indiana welcome.

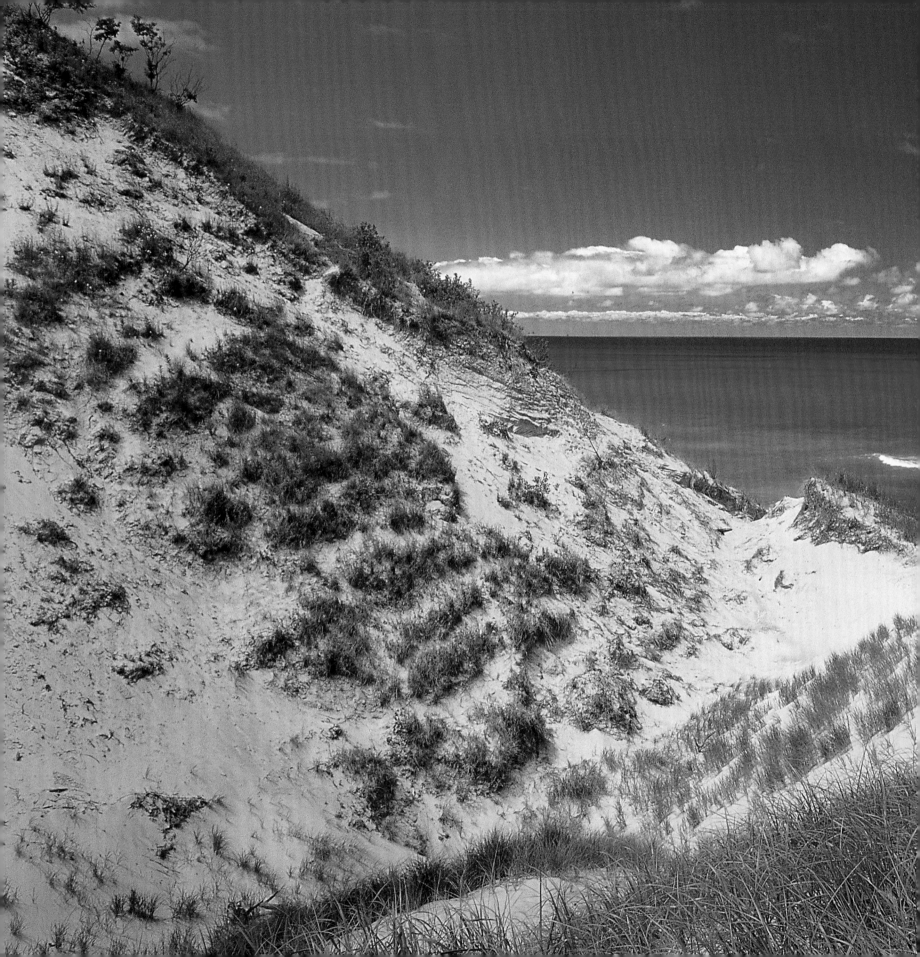

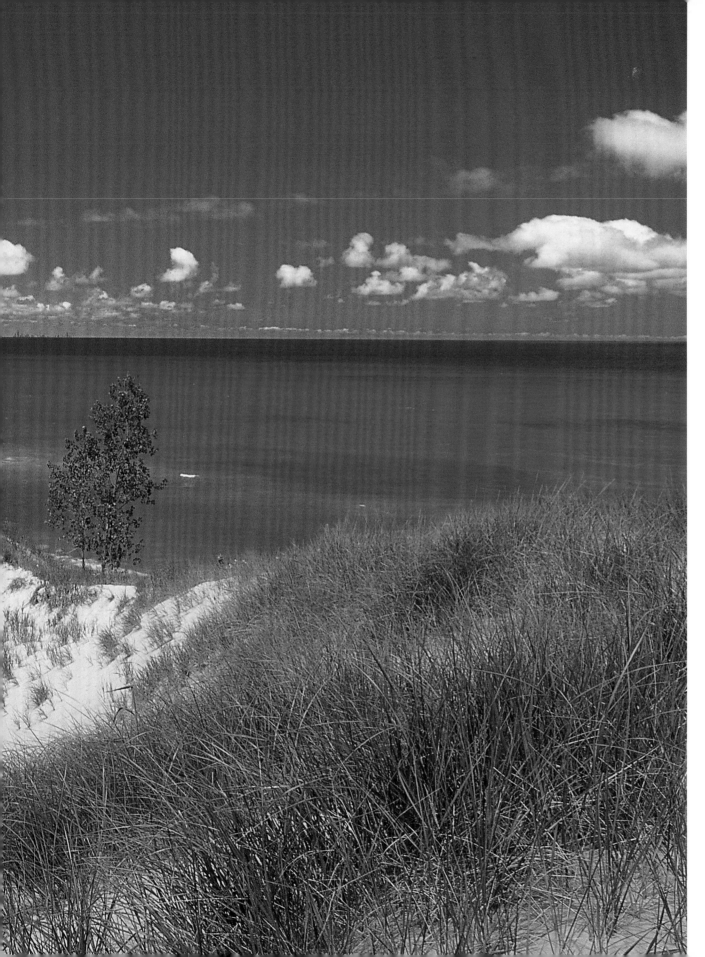

From Indiana Dunes National Lakeshore, the skyline of Chicago is barely visible in the distance. The 15,000-acre park protects the pristine sands along the shores of Lake Michigan, as well as a 1930s fur-trader's homestead and a working re-creation of a farm from the early 1900s.

From the hardy grasses that grow along the sands to the wildflowers of the bogs and wetlands, there are 1,418 types of plants within Indiana Dunes National Park, including more than 90 endangered species. The preserve boasts the seventh-highest plant diversity among national parks in the United States.

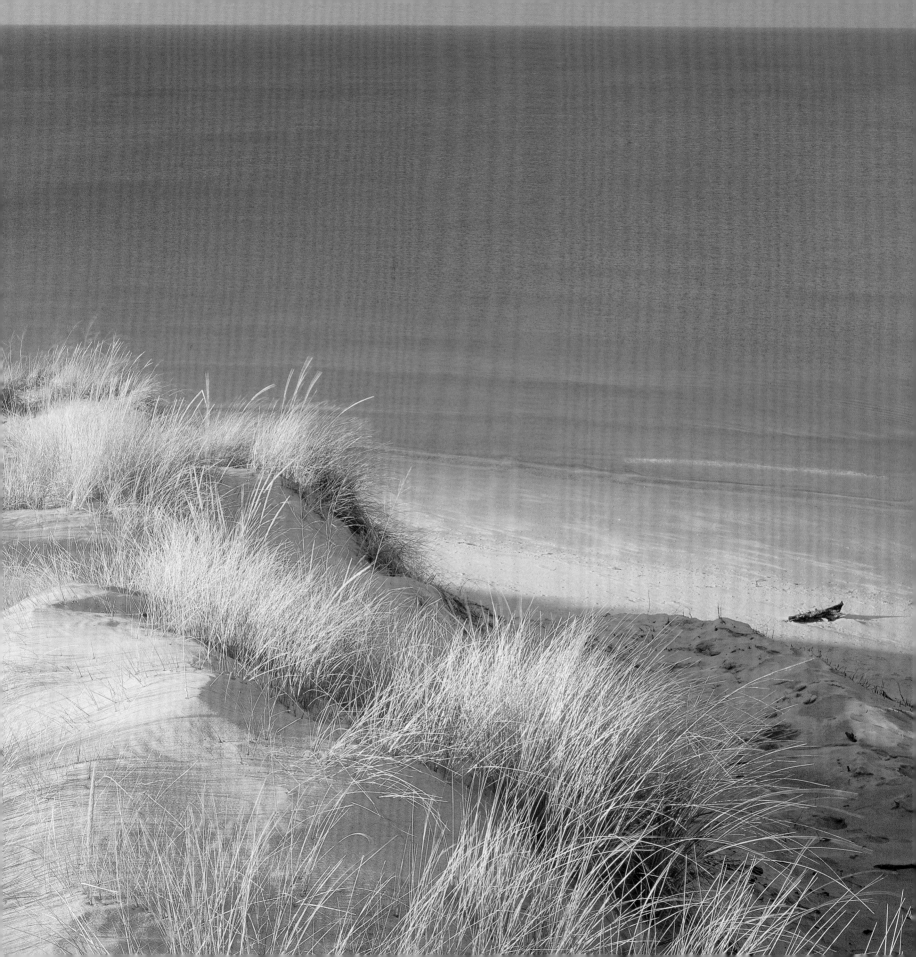

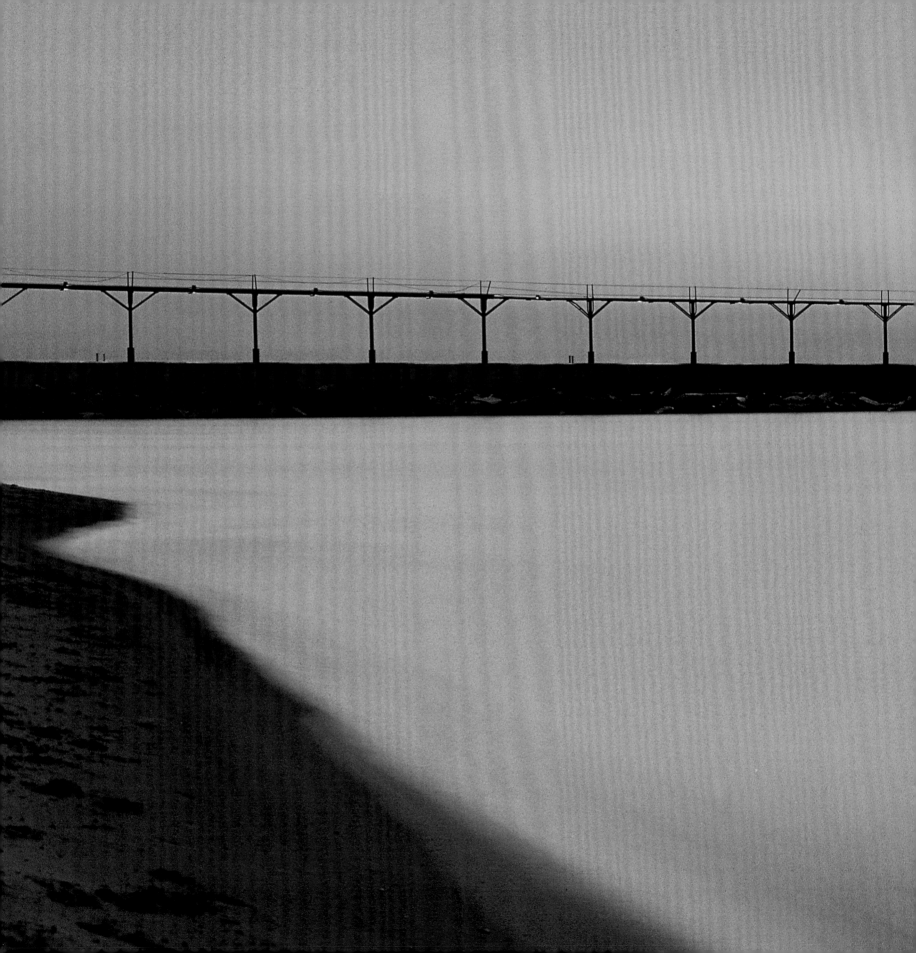

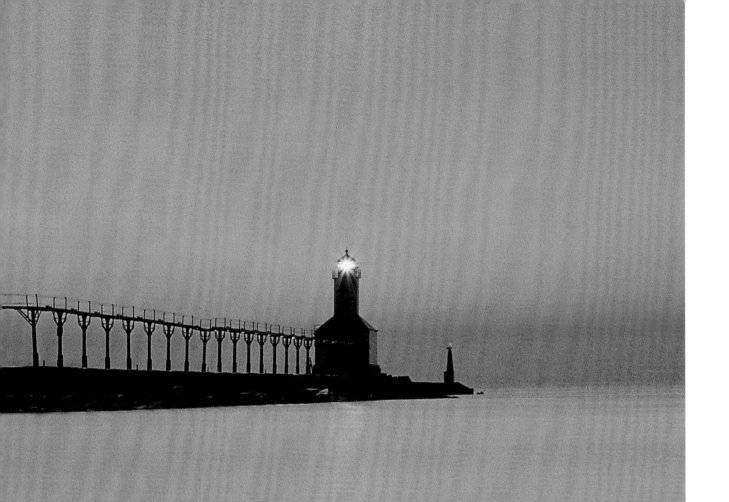

The Michigan City
East Pier Lighthouse
was built in 1904 to
guide the ships that
arrived in the city's
harbor to collect
their cargoes of grain
and lumber. The
49-foot beacon
was automated in
1960 and remains
operational today.

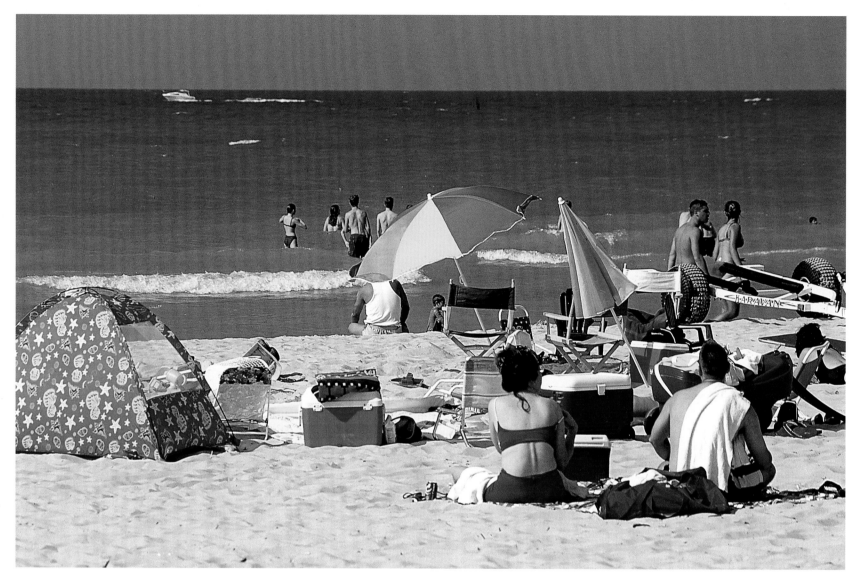

Each summer, sunbathers and swimmers crowd Lake Michigan's southern white sand beaches protected by Indiana Dunes State Park. The preserve's 2,182 acres also envelop shaded woodlands and rolling sand hills, campsites, picnic spots, hiking and cross-country skiing trails, and more.

The Old Michigan City Light was built in 1858 and was tended by Harriet Colfax, one of the few women lighthouse keepers on the Great Lakes, until 1904, when she reluctantly retired at 80.

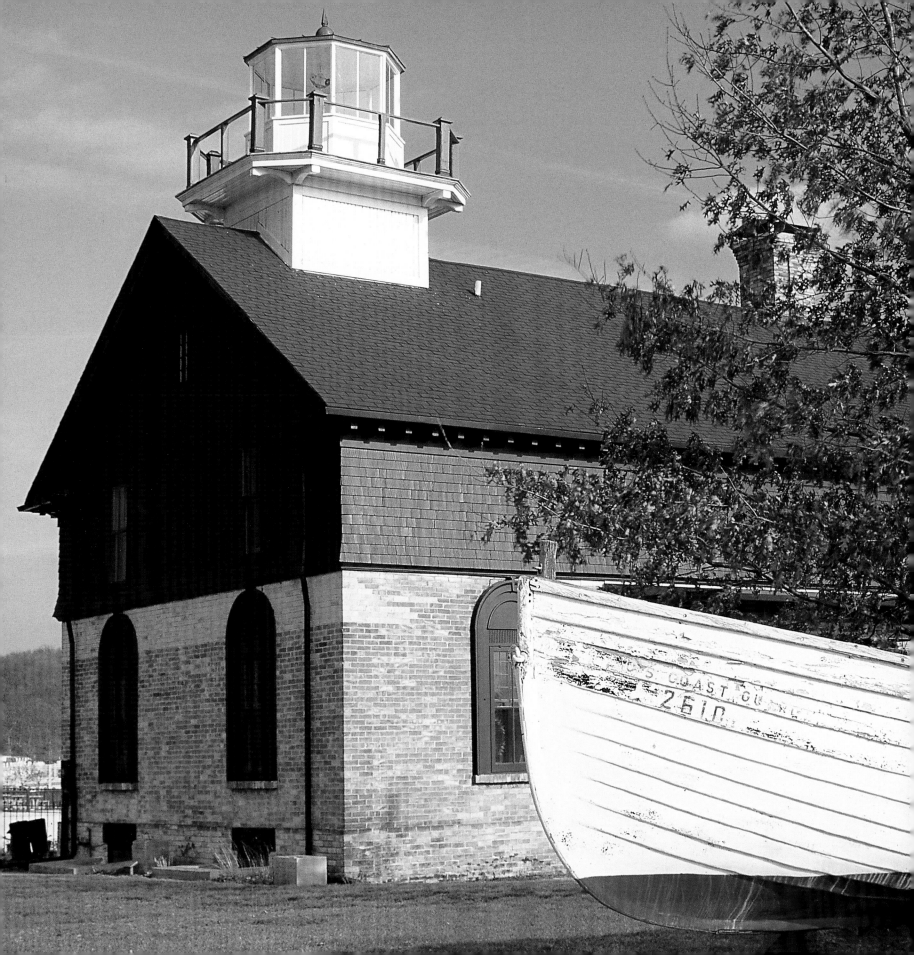

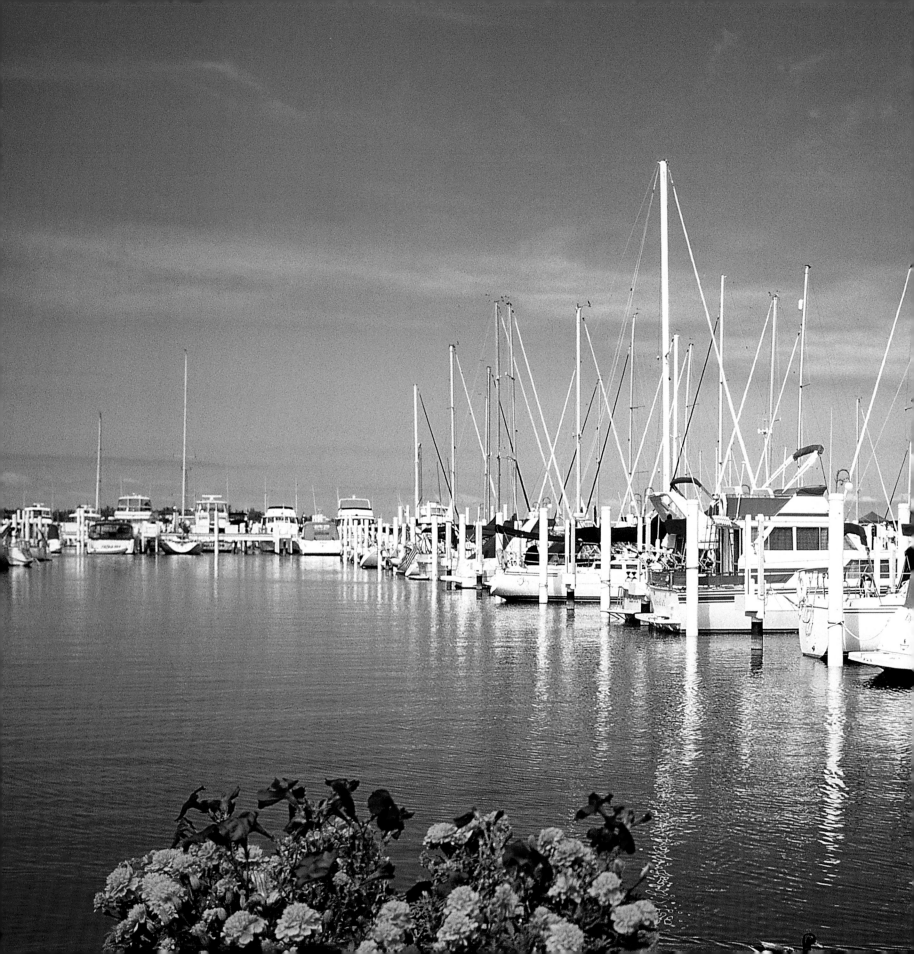

Sailboats rest on the sheltered waters of Washington Park in Michigan City. In 1836, the community was home to lumber mills and grist mills, shipping companies and 1,500 settlers.

The interior ceiling of the Basilica of the Sacred Heart at the University of Notre Dame soars 60 feet above the pews. The basilica also showcases an opulent gold altar, 42 intricate stained-glass windows, and murals painted by Vatican artist-in-residence Luigi Gregori. The paintings took 17 years to complete.

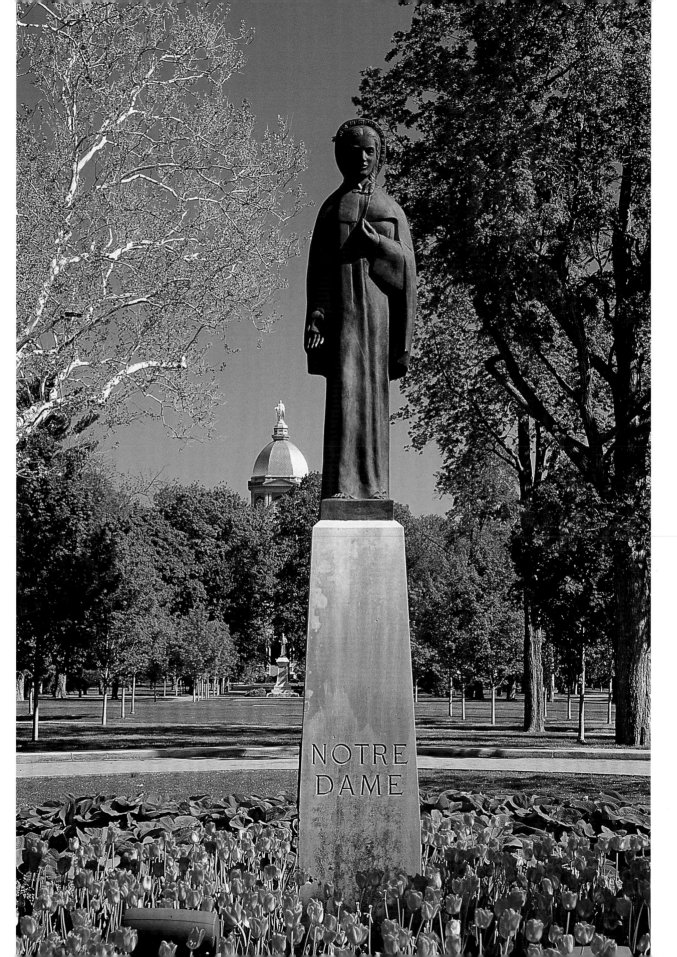

Father Edward Sorin founded the University of Notre Dame in 1842. Today the Catholic institution enrols more than 10,000 students. Admission is competitive—about 40 percent of first-year students were among the top five graduates of their high-school classes.

17

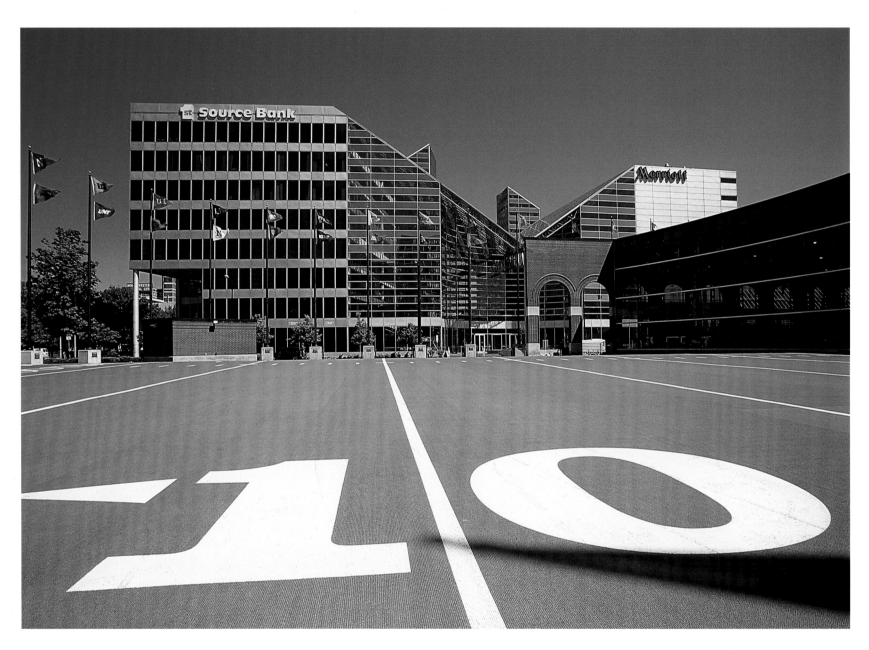

From the Gridiron Plaza to the Hall of Champions and its more than 800 star players, the College Football Hall of Fame in South Bend is filled with interactive displays and exhibits.

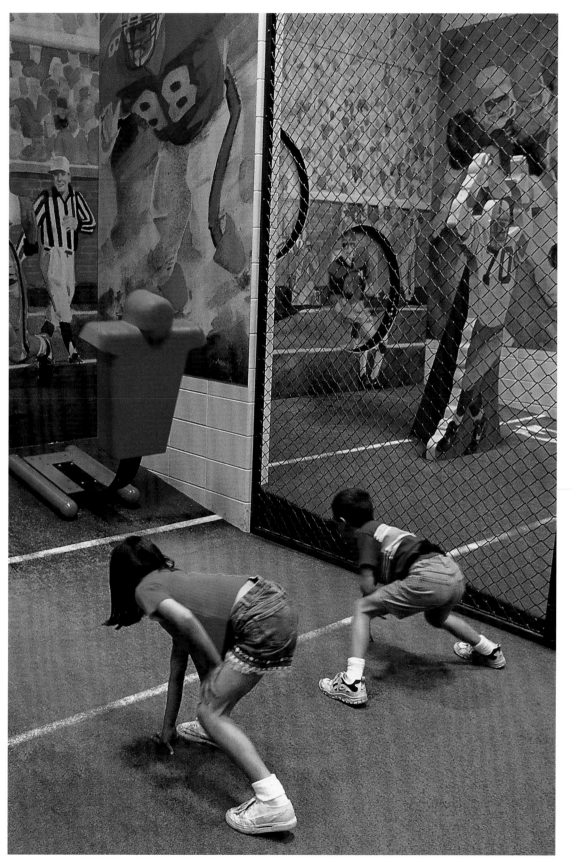

After being "tested" in the Training Room, young football enthusiasts can hone their kicking, throwing, and tackling skills on the Practice Field inside the College Football Hall of Fame. Afterwards, it's off to the re-creation of a 1930s locker room.

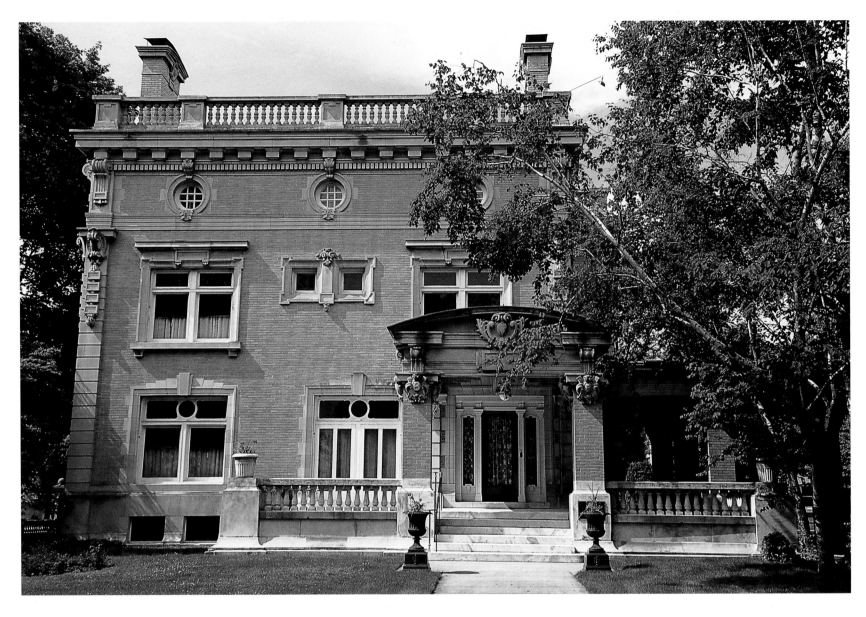

Elkhart businessman Albert R. Beardsley and his wife, Elizabeth, built this three-story mansion on the banks of the Saint Joseph River in 1908, using as many local materials as possible. They named their home Ruthmere, in honor of their only child who had died in infancy.

The city of Elkhart is a major commercial center, home to more than 900 manufacturers and 850 wholesalers. Yet the community strives to balance its industrial side with quiet neighborhoods, attractive river and lakeside parks, and cultural activities.

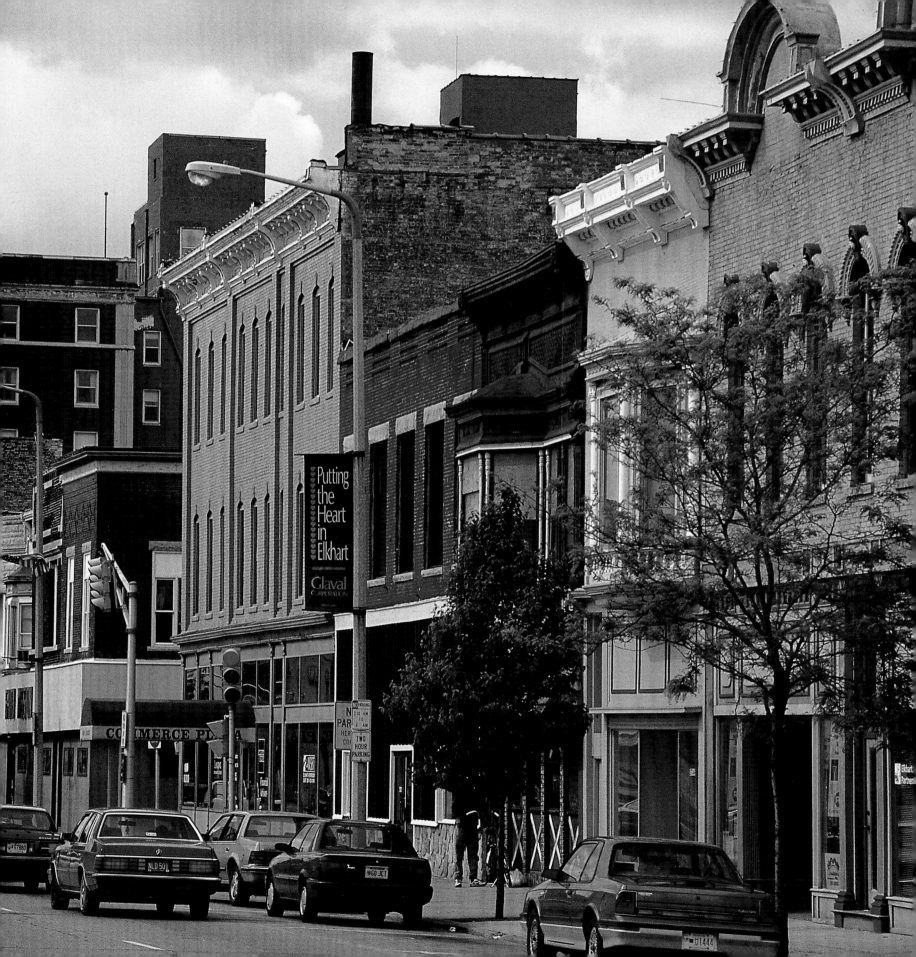

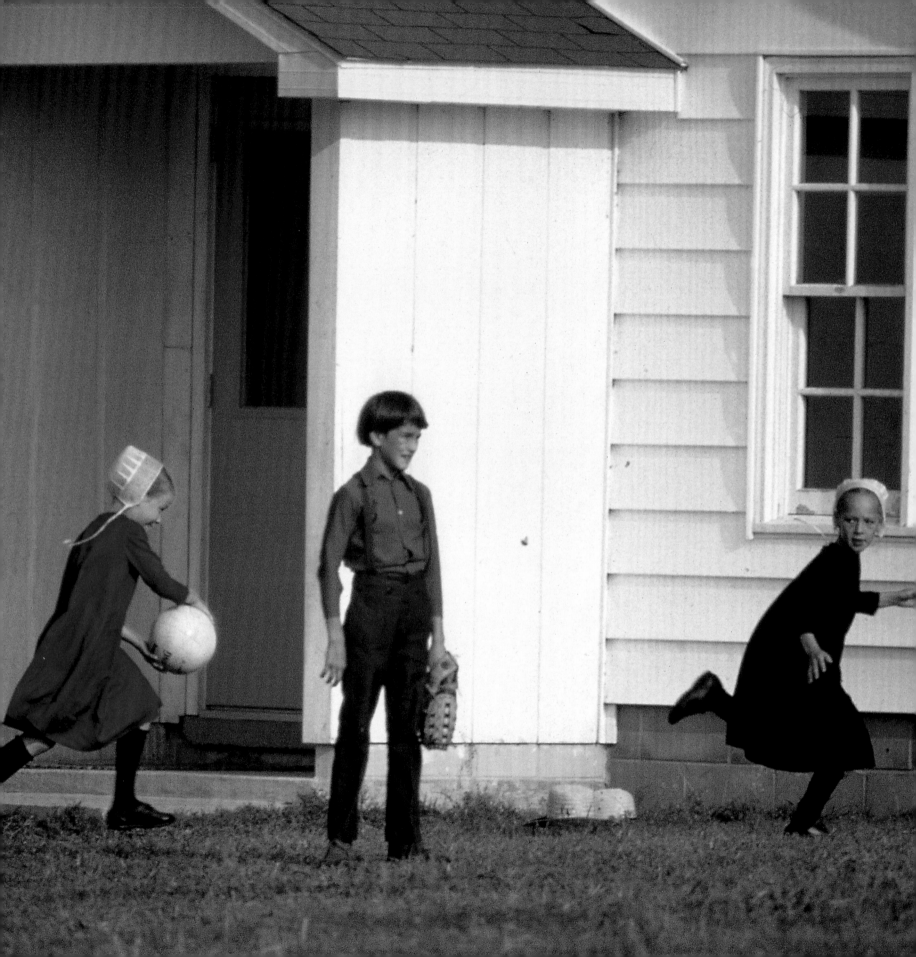

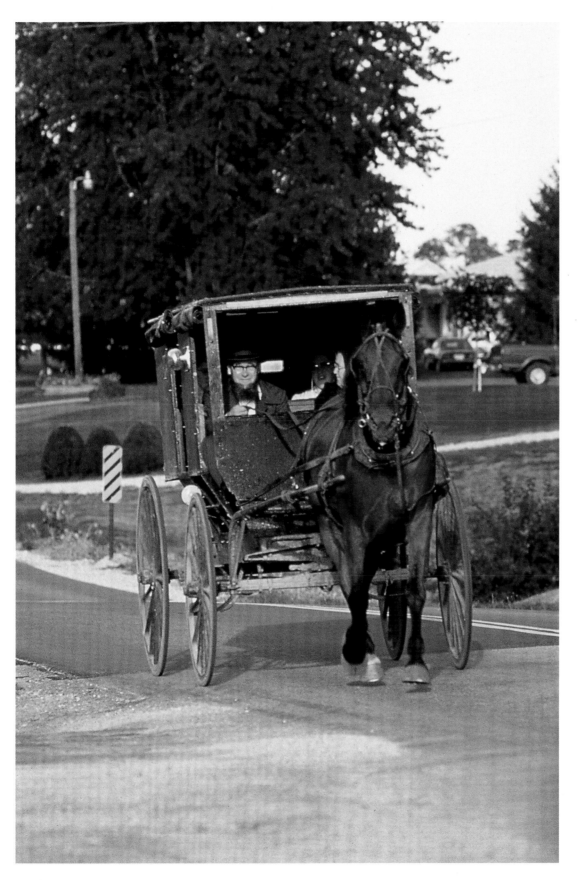

The Amish people of Indiana believe that remaining separate from society helps them to live simply and modestly and to better adhere to the will of God. They avoid technology such as electricity, televisions, and automobiles that would more closely connect them to the outside world.

FACING PAGE—
Mennonite and Amish people have made their homes in northern Indiana since the 1840s, when small groups from both sects found plentiful farmland in the area. Today, visitors to Shipshewana find horse-drawn buggies sharing the roads with automobiles. Local shops offer distinctive quilts and handmade furniture.

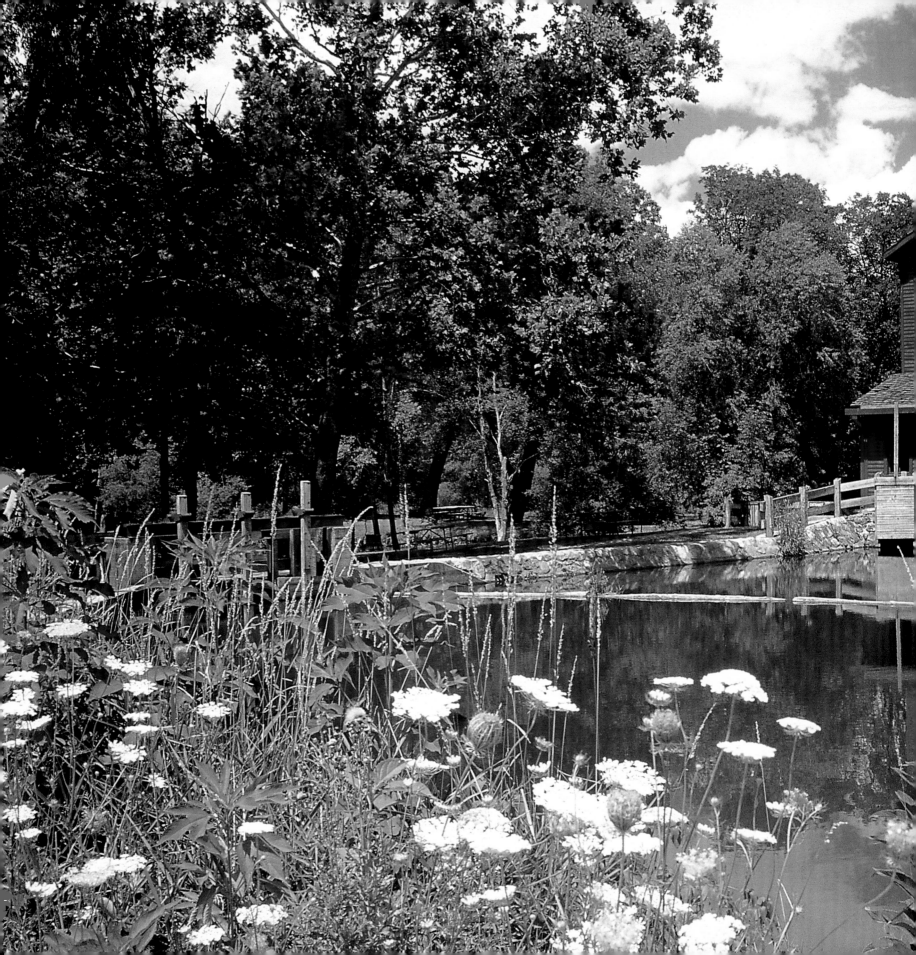

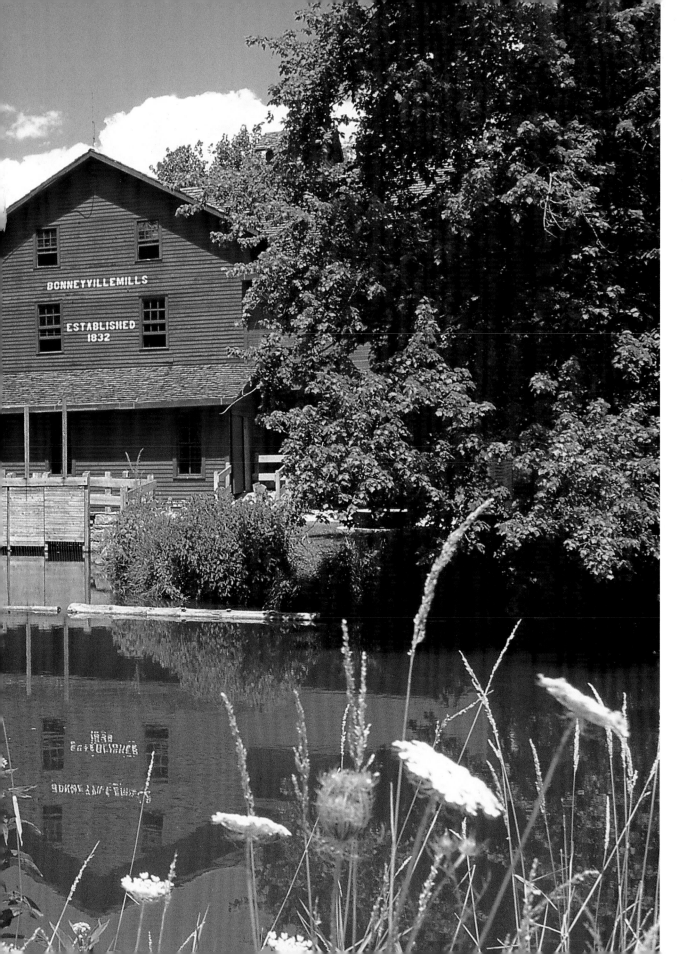

Built in the 1830s, the water-powered mill at Bonneyville Mill County Park was the creation of Edward Bonney, a businessman who envisioned a bustling trading center surrounding his enterprise. When the railways bypassed the site, Bonney's dream was shattered. The mill, however, has continued to produce stone-ground flour for the last 150 years.

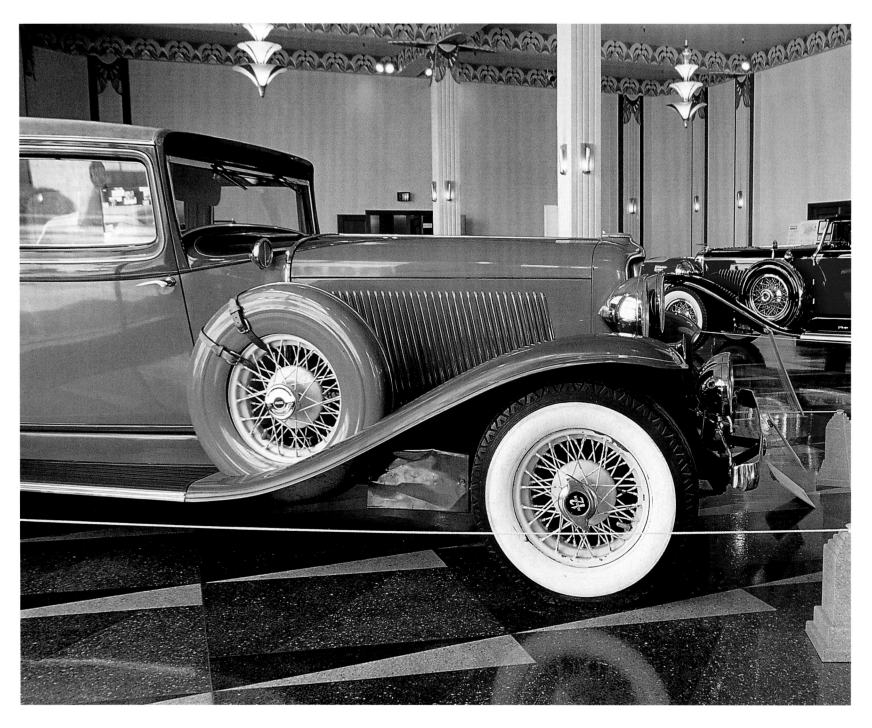

The Auburn-Cord-Duesenberg Museum showcases more than
100 classic cars in the restored factory showrooms of the Auburn
Automobile Company. Between 1901, when it released the first
Auburn, and its peak in the 1930s, the company produced
thousands of luxury automobiles and sports cars.

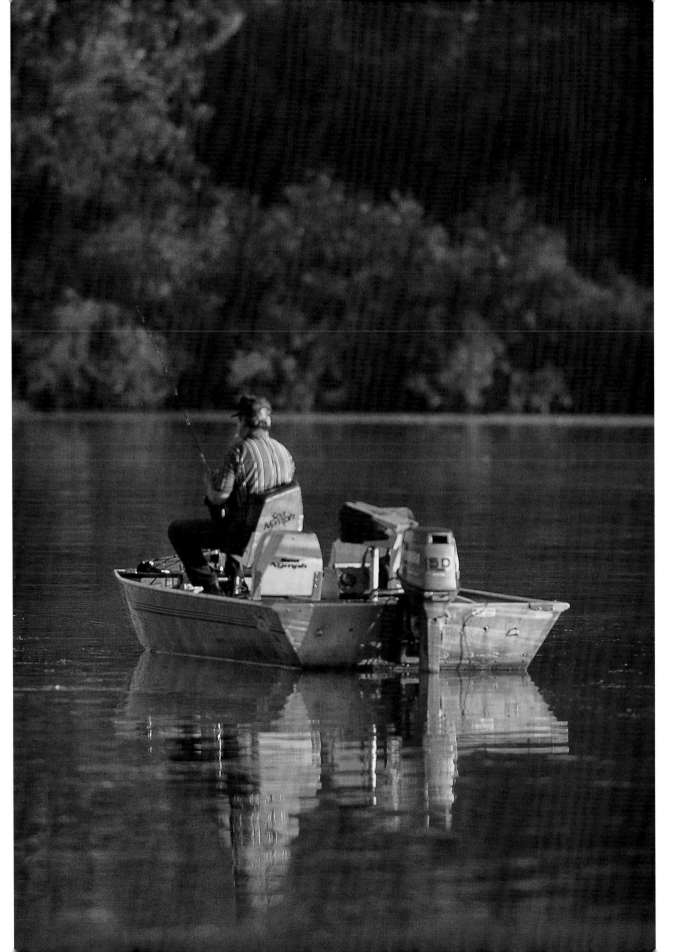

An angler tries his luck in Silver Lake, just south of Warsaw. There are about 1,000 small lakes in Indiana, home to largemouth bass, catfish, bullhead trout, walleyes, bluegills, and northern pike.

Fort Wayne has been a center for art since the late 1800s. With local collector Theodore Thieme's donation of ten paintings in 1921, the Fort Wayne Museum of Art was born. The 40,000-square-foot gallery now houses more than 1,300 pieces.

Farmers began building round barns in Indiana in 1910, possibly in imitation of horse-powered treading mills, wigwams, or roundhouses built to turn steam locomotives. This barn, built in 1924, was later donated to the Fulton County Historical Society.

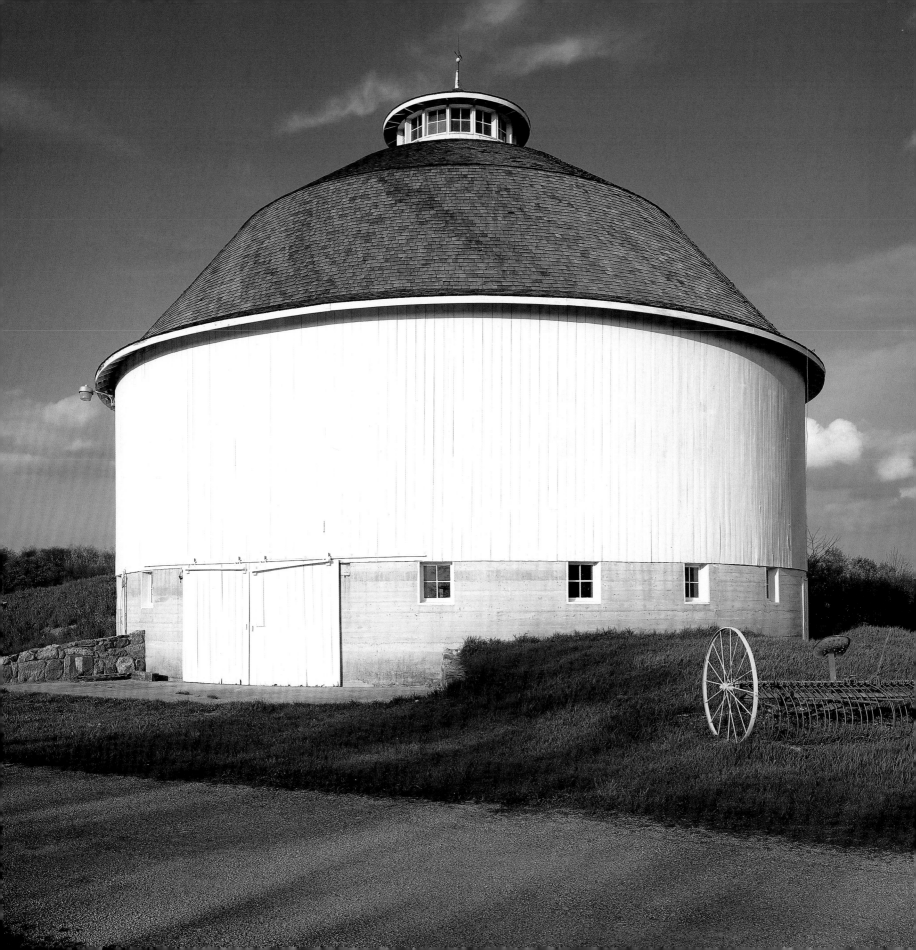

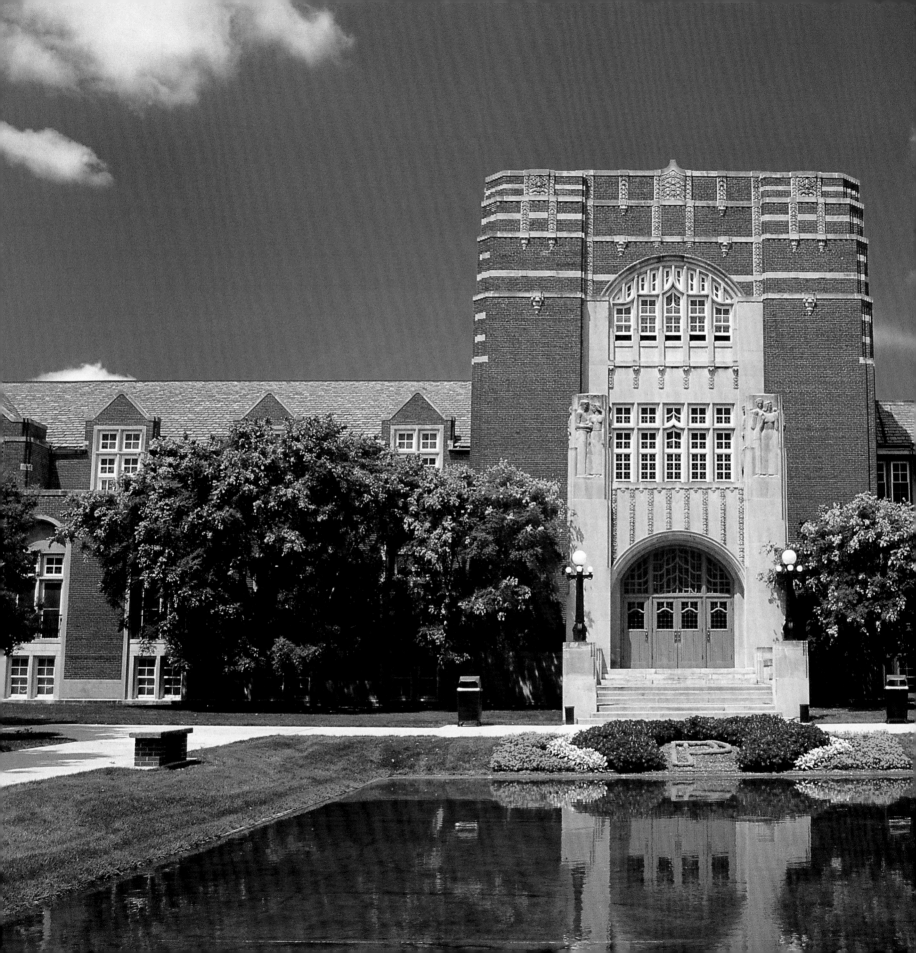

Best known for its engineering and agriculture programs, Purdue University in West Lafayette offers more than 6,000 courses in 200 specialities. The school was founded in 1869 and named for one of its first benefactors, local businessman and financier John Purdue.

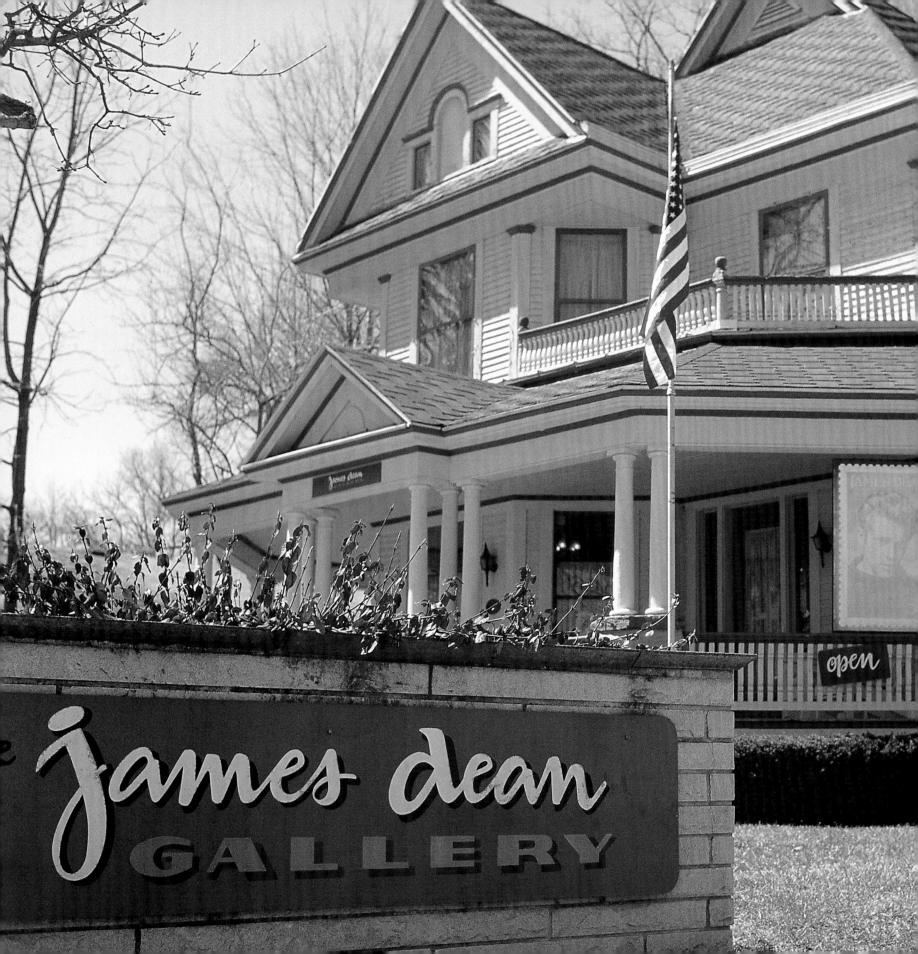

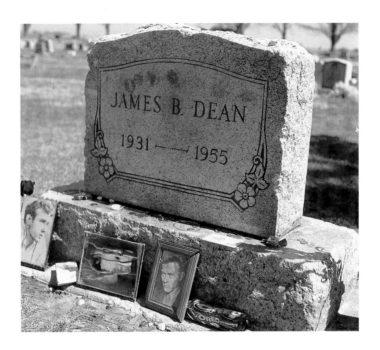

James Dean's gravesite in Fairmount attracts thousands of fans each year. Best known for his roles in *East of Eden, Rebel Without a Cause,* and *Giant*, Dean died in an automobile accident in 1955, at the age of 24.

The James Dean Memorial Gallery in the actor's hometown of Fairmount features seven rooms of memorabilia, from clothing and high-school yearbooks to snapshots and paintings by James Dean himself. Collector David Loehr founded the gallery in 1988.

Even after much of the crop is used to feed livestock, corn accounts for half of Indiana's crop sales. In total, Indiana farmers harvest more than 5.7 million bushels each year.

A small creek carves a path through the limestone of Warren County. Like much of northern and central Indiana, Warren County was covered by glaciers 10,000 years ago. When they retreated, they left behind lowlands of rich soil, punctuated by rocky, rolling hills.

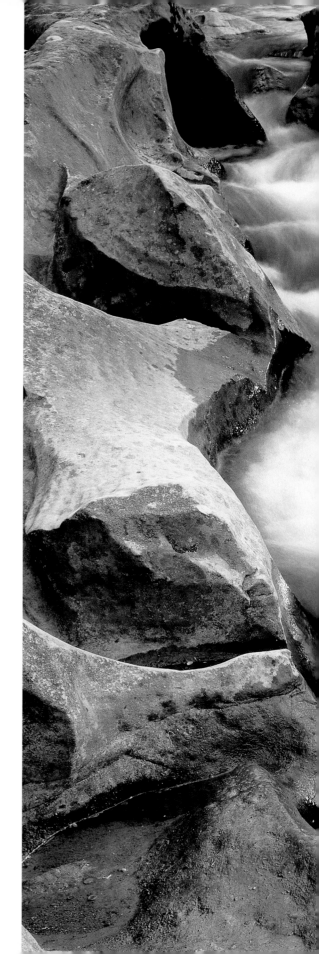

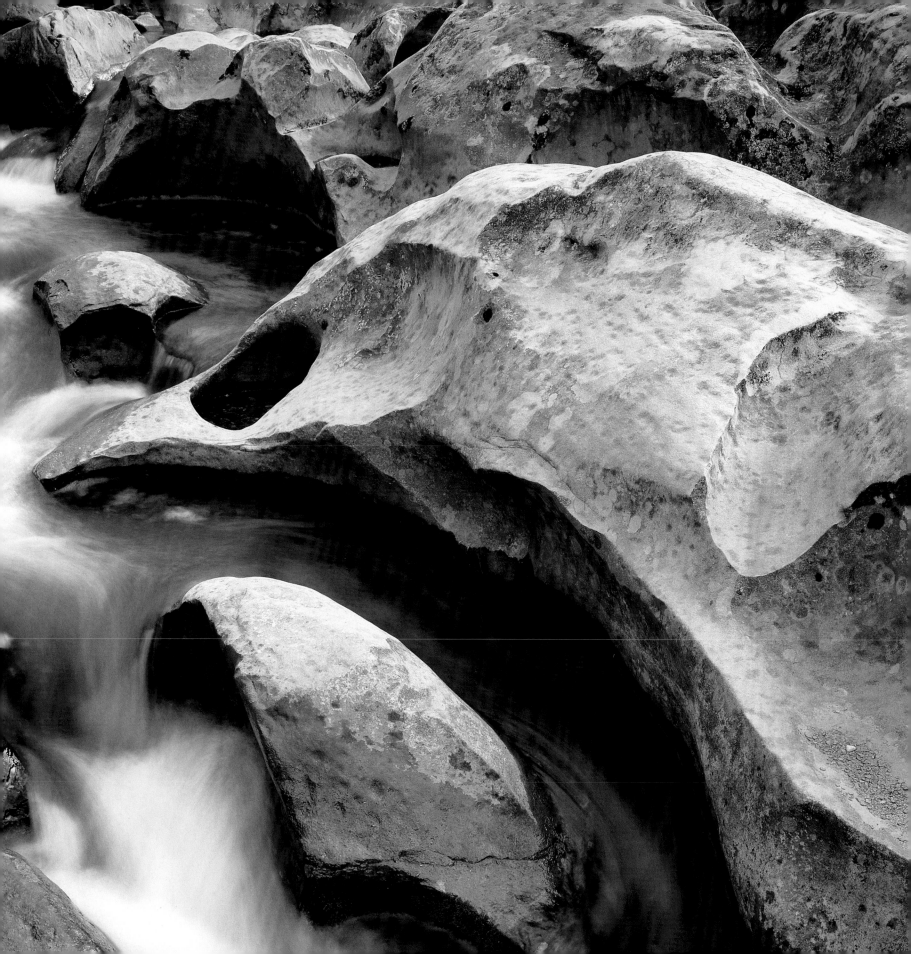

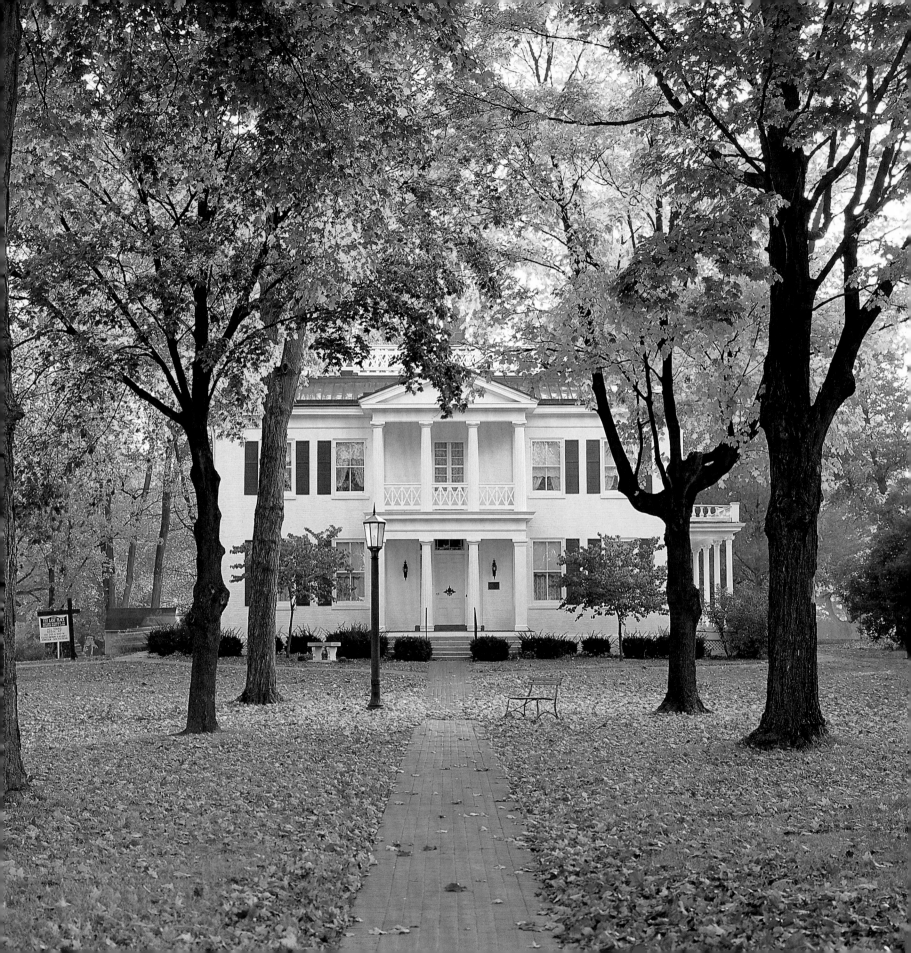

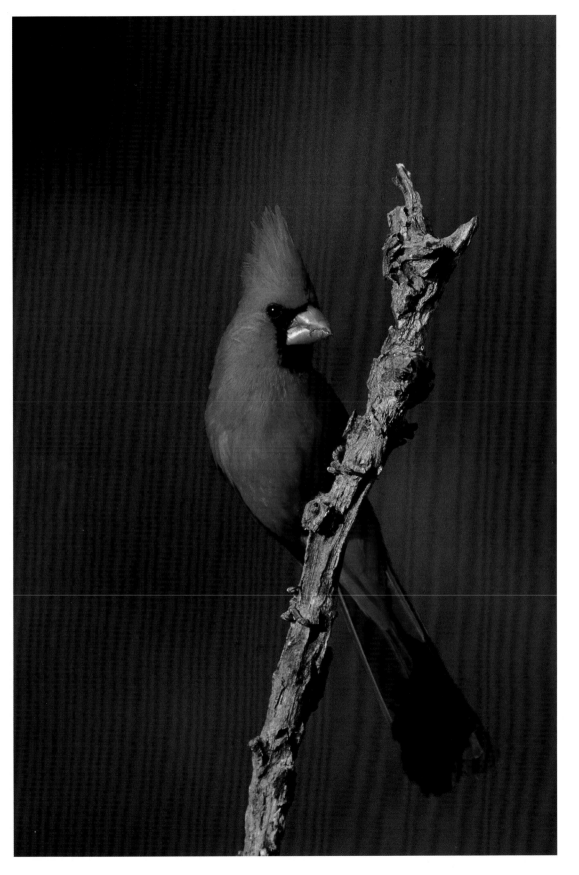

Cardinals, the official state bird, live year-round in Indiana's scrub grasses and meadows. Male birds such as this one, with their red plumage, are easily spotted at backyard feeders. The cardinal's cone-shaped red bill is a powerful tool for cracking seeds and nuts.

FACING PAGE—
Senator Henry S. Lane is best known for helping secure Abraham Lincoln's nomination for the presidency. Lane and his wife, Joann, built this mansion in Crawfordsville in 1845. Listed on the National Register of Historic Places, the restored home is now open to the public and showcases 10 rooms with the original furnishings.

One of Indiana's first preserves, Turkey Run State Park was established in 1916. The park's name originates from the way early homesteaders hunted wild turkeys, herding them into natural "runs" formed by the area's steep canyon walls.

Splendid Parke County, on Indiana's western border, encompasses several wilderness areas popular with swimmers, canoeists, hikers, and anglers. The county also draws history enthusiasts with 32 covered bridges and two old grist mills.

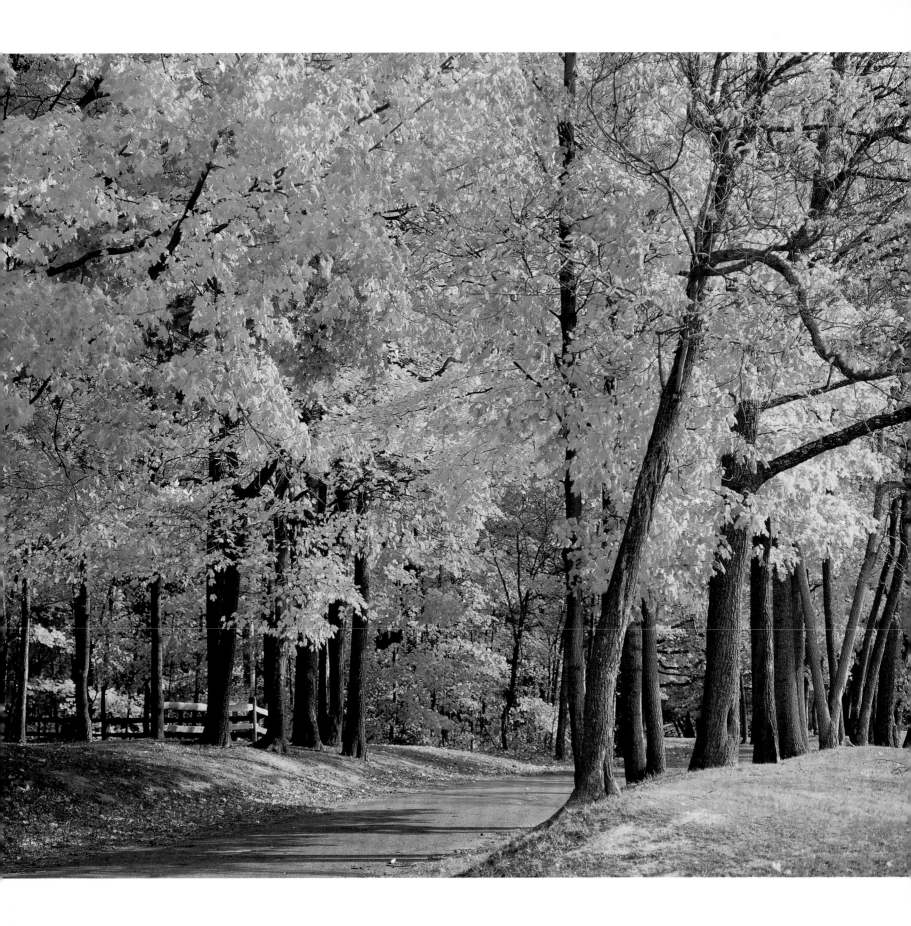

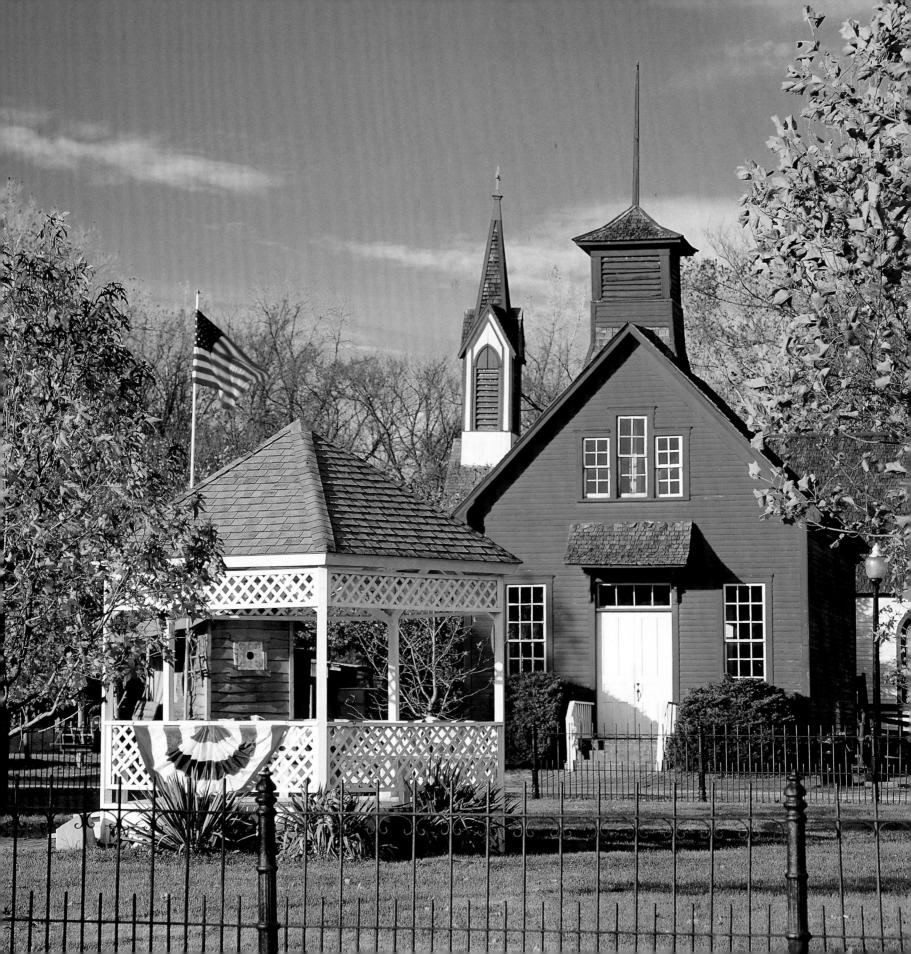

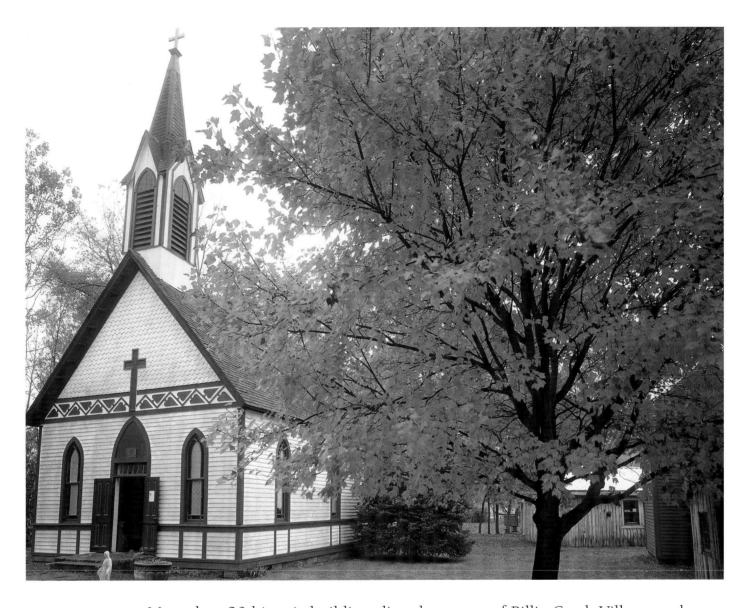

More than 30 historic buildings line the streets of Billie Creek Village, and dirt roads lead to three restored covered bridges. Sightseers can ride a horse and carriage into town to discover themselves in the midst of a Civil War battle, a county fair, or a community celebration.

At Billie Creek Village, visitors experience life in the early twentieth century. The general store sells homemade fudge and maple syrup, potters and boat builders demonstrate their crafts, and a blacksmith stokes a nearby forge.

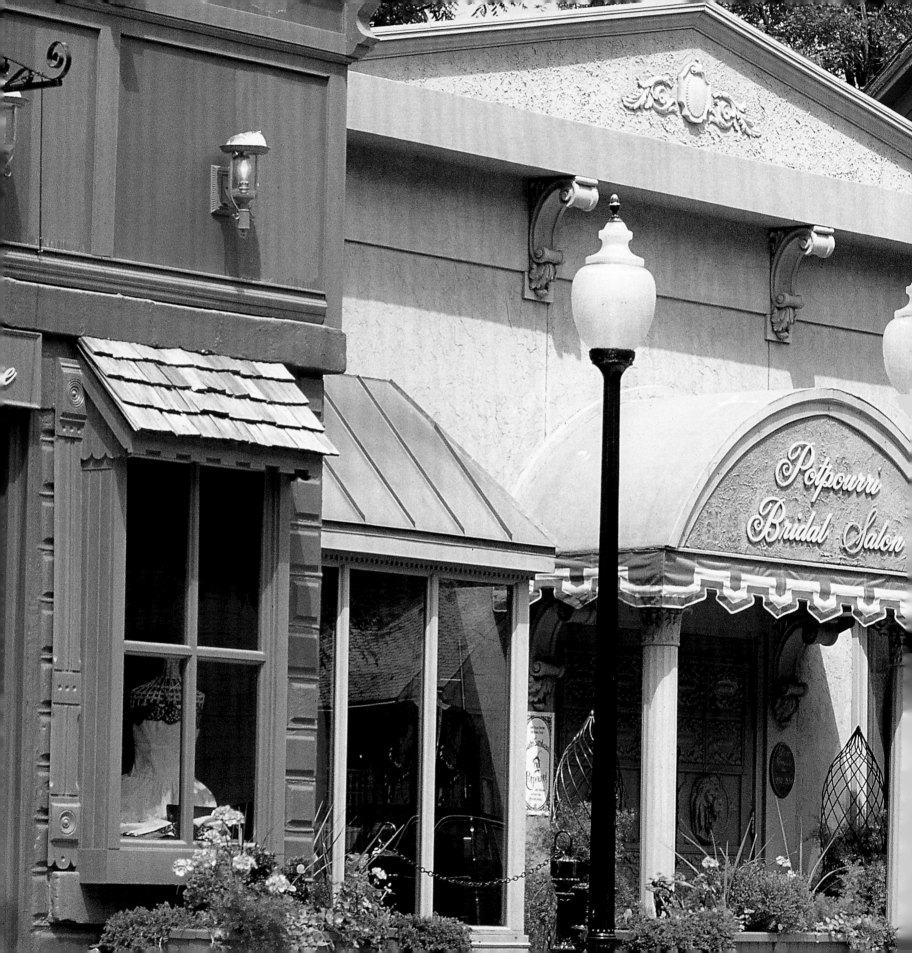

At the edge of Indianapolis, the main street of Zionsville greets shoppers with heritage-style brick buildings. Upscale boutiques and charming eateries provide a respite from the bustle of the city core. Nineteenth-century homes nestle along tree-lined streets nearby.

43

America's twelfth-largest city, Indianapolis and the surrounding metropolitan area are home to 1.6 million people and host 18 million visitors each year. The city sprang up along the National Road of the 1830s, was soon a center for canal and railway travel, and is now bisected by more highways than any other American City. Indianapolis has earned the nickname Crossroads of America.

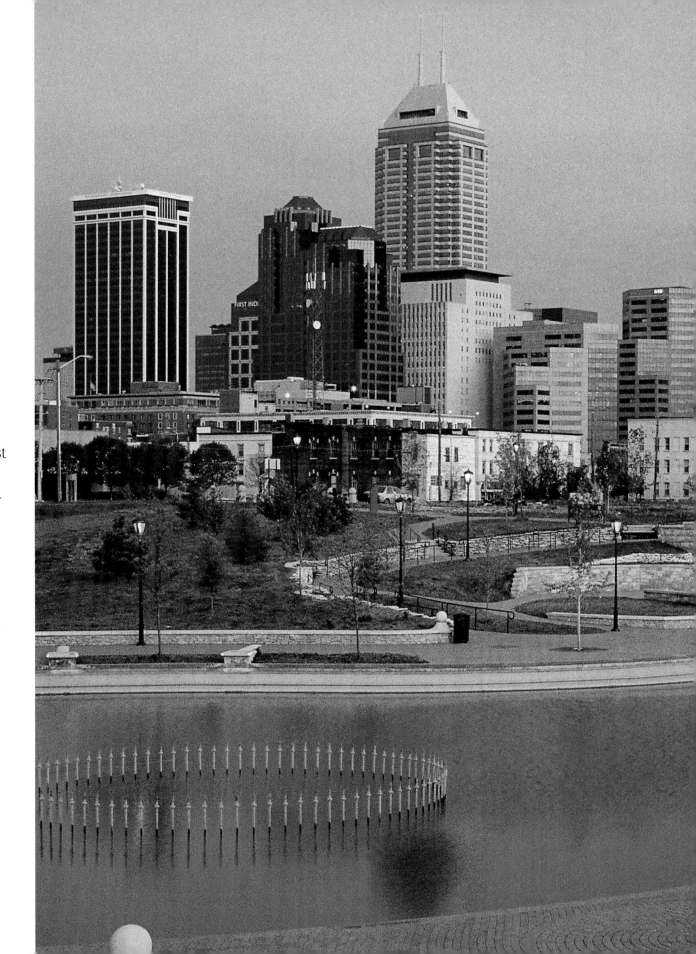

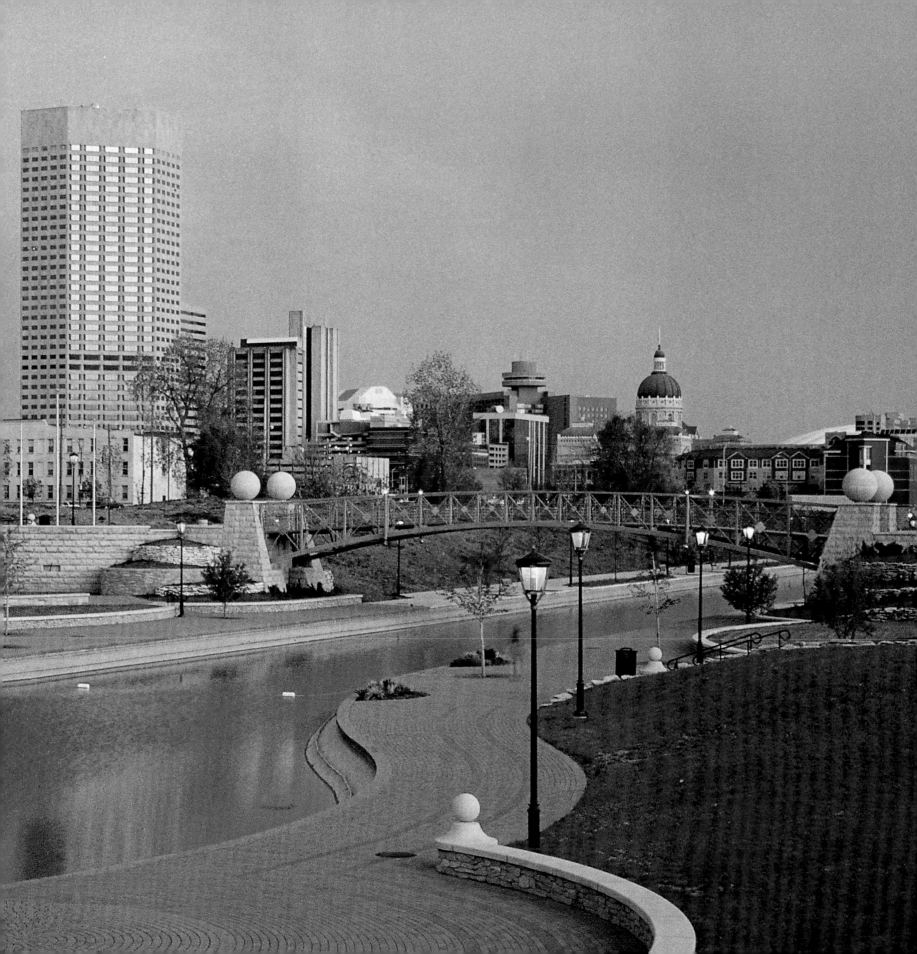

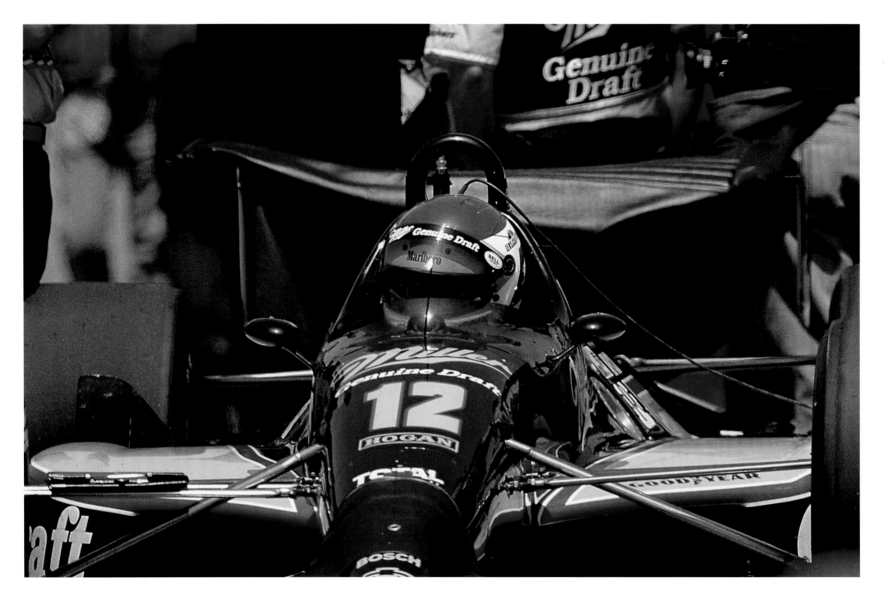

Each May, the Indianapolis 500 draws thousands of racing enthusiasts to the Indiana Motor Speedway. The Hall of Fame Museum next door displays 75 racing cars, as well as trophies, helmets, engines, and photographs, all tributes to the sport's enduring popularity.

Many of the buildings in Indianapolis's oldest neighborhood, Lockerbie Square, date from the late 1800s. In the 1960s, this was one of the city's first historic neighborhoods to be restored and revitalized. It was listed in the National Register of Historic Places in 1973.

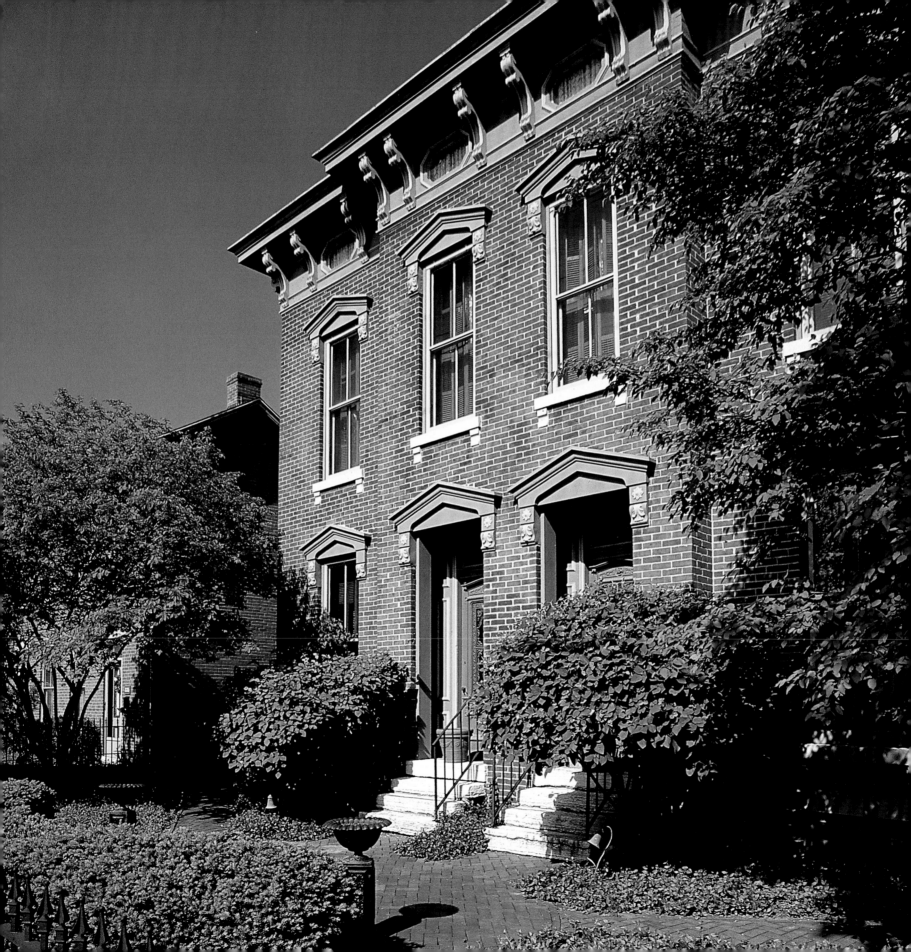

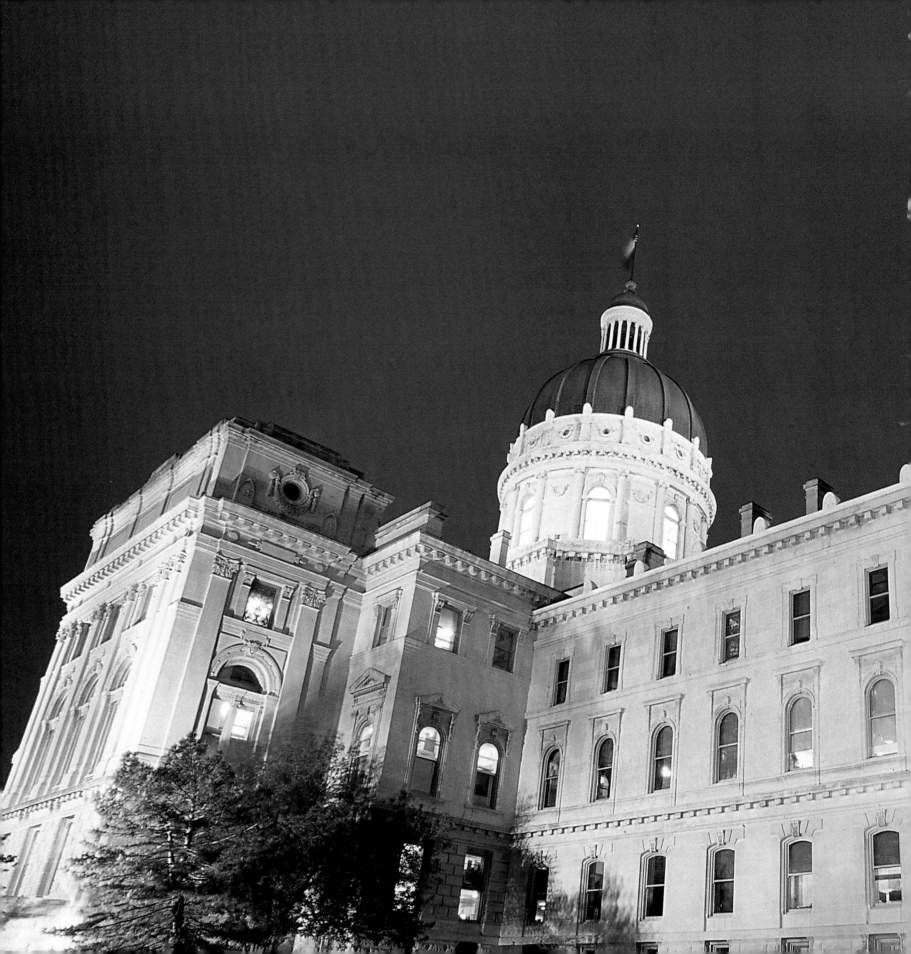

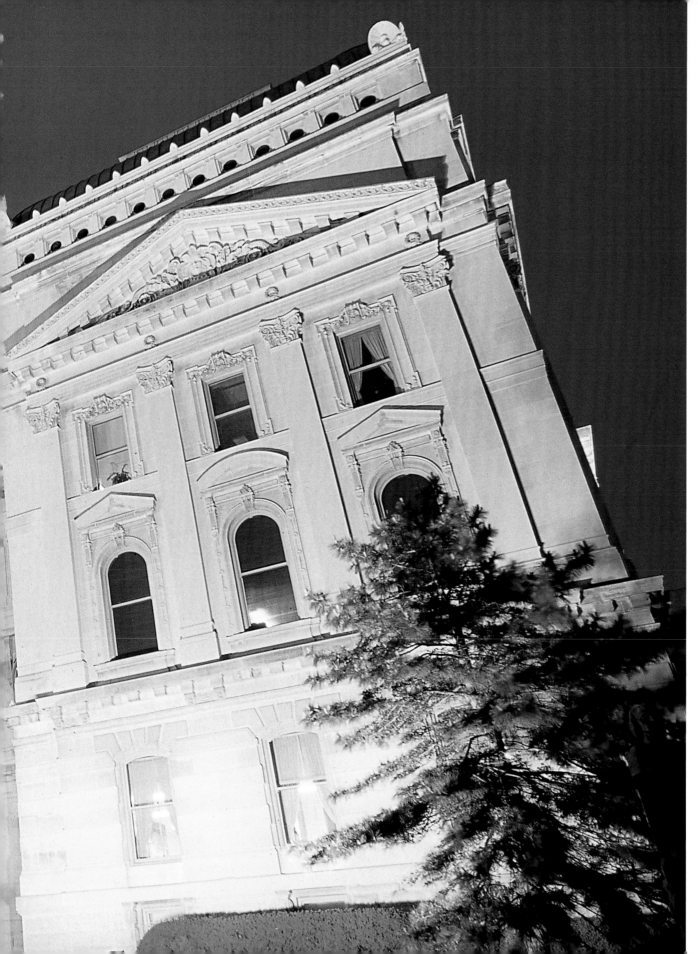

Designed by Edwin May, Indiana's State Capitol was completed in 1886, six years after the architect's death. The Renaissance Revival-style building cost $2 million to build; a renovation in the late 1980s cost more than five times that amount.

49

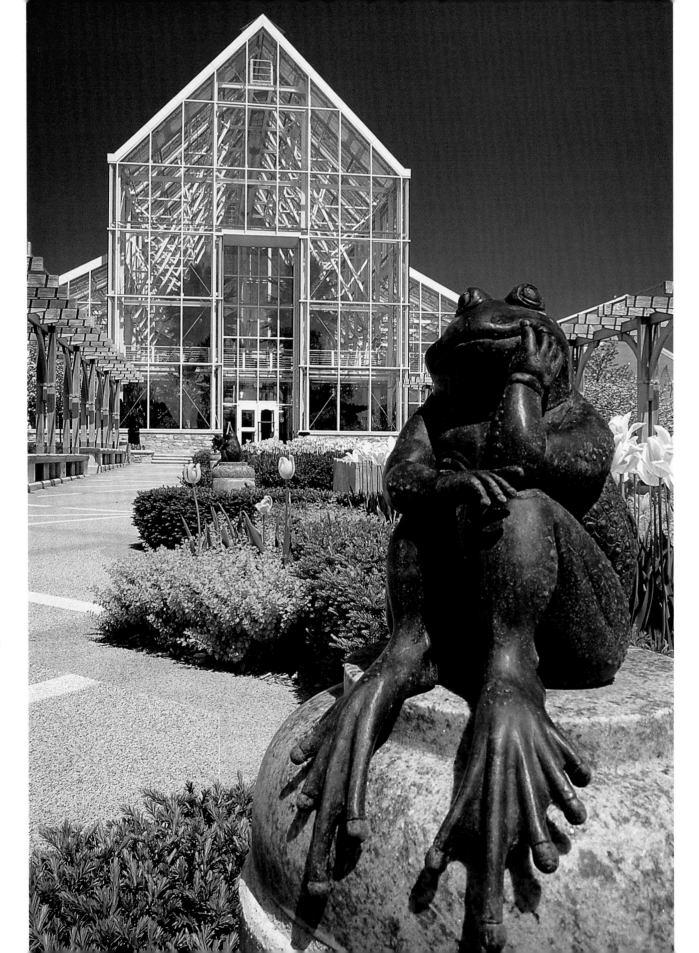

White River Gardens, which adjoin the Indianapolis zoo, is a lush 3.3-acre oasis of more than 1,000 plant varieties. The combination of elegant manicured gardens, water features, and meandering pathways strives to bring people and nature closer together.

50

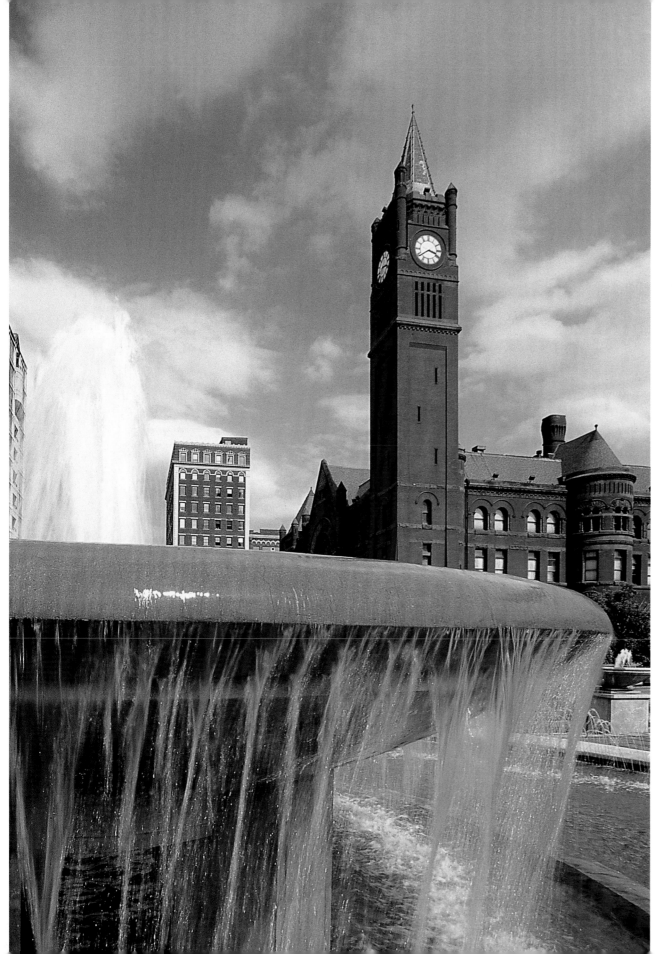

Listed on the National Register of Historic Places, Union Station in Indianapolis was completed in 1888 to replace an earlier station and meet the needs of the growing commercial center. In the early 1900s, at the peak of railway travel, more than 200 trains stopped here each day.

51

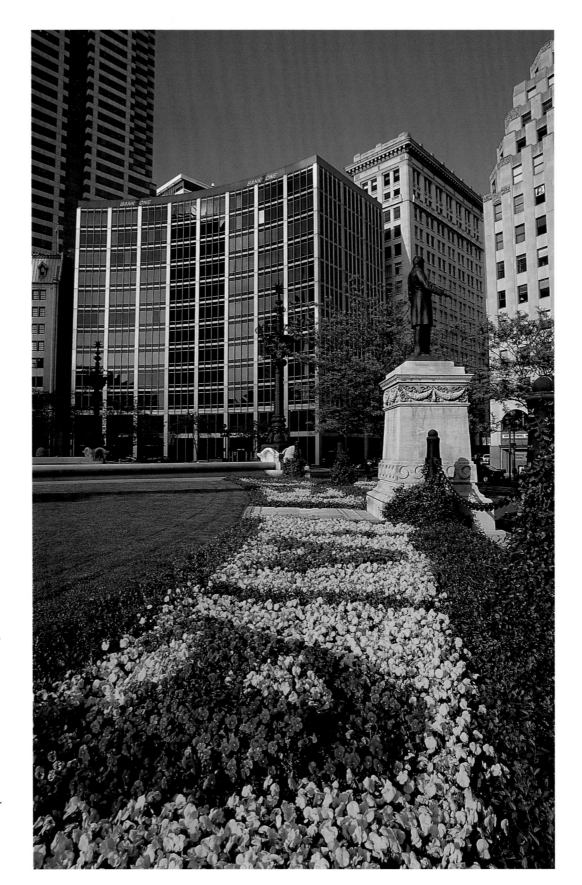

At the heart of Indianapolis, Monument Circle is home to Christ Church Cathedral, built in 1857, and the Soldiers' and Sailors' Monument, completed in 1902. Sculptures and structures throughout the city honor those who died in America's past battles, firefighters and police officers, and Medal of Honor recipients.

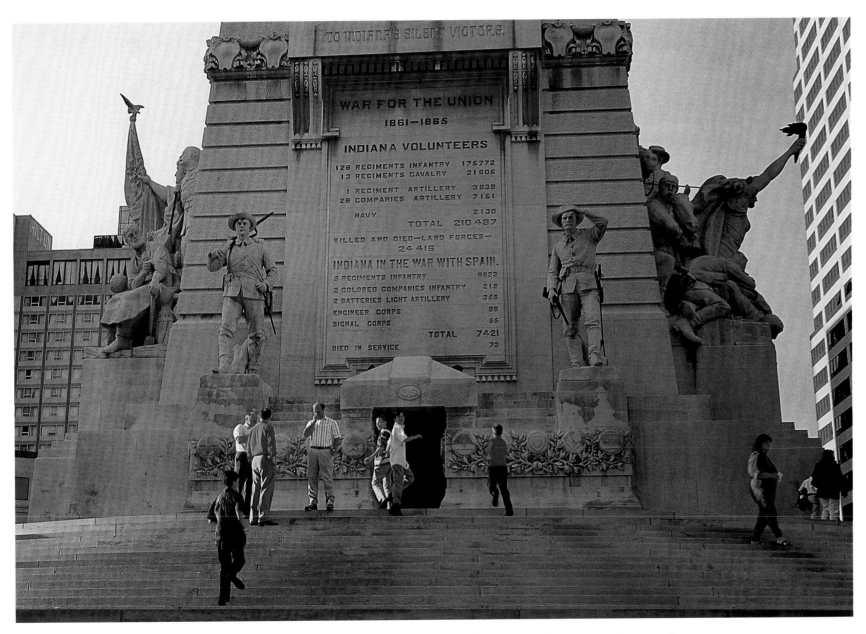

TO INDIANA'S SILENT VICTORS.

WAR FOR THE UNION

1861-1865

INDIANA VOLUNTEERS

126 REGIMENTS INFANTRY		175772
13 REGIMENTS CAVALRY		21605
1 REGIMENT ARTILLERY		3838
26 COMPANIES ARTILLERY		7151
NAVY		2130
	TOTAL	210 487

KILLED AND DIED—LAND FORCES—
24 416

INDIANA IN THE WAR WITH SPAIN.

5 REGIMENTS INFANTRY	6692
2 COLORED COMPANIES INFANTRY	219
2 BATTERIES LIGHT ARTILLERY	358
ENGINEER CORPS	98
SIGNAL CORPS	55
TOTAL	7421
DIED IN SERVICE	73

The Soldiers' and Sailors' Monument honors Indiana residents who fought in wars before World War I. On the first floor, the Col. Eli Lilly Civil War Museum features soldiers' letters and diaries as well as illustrations and artifacts. Thirty-two stories up, the monument's observation deck provides a panoramic view of the city.

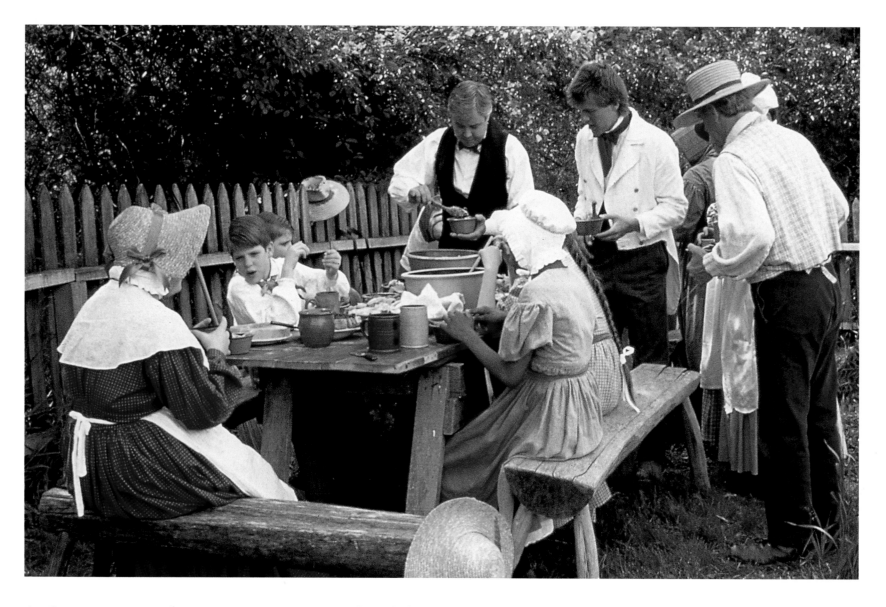

At Conner Prairie, the West was never tamed and the wild frontier lives. Once the home of early nineteenth-century trader and entrepreneur William Conner, the site now includes a Lenape native camp and historic buildings from across Indiana. Costumed staff host an 1835 wedding feast to illustrate the life of the region's pioneers.

Workers completed the Whitewater Canal in 1843, but like many others, the canal was doomed by inadequate trade, floods, and the coming of the railways. A restored portion of the waterway, including America's last wooden aqueduct, draws sightseers to the historic town of Metamora.

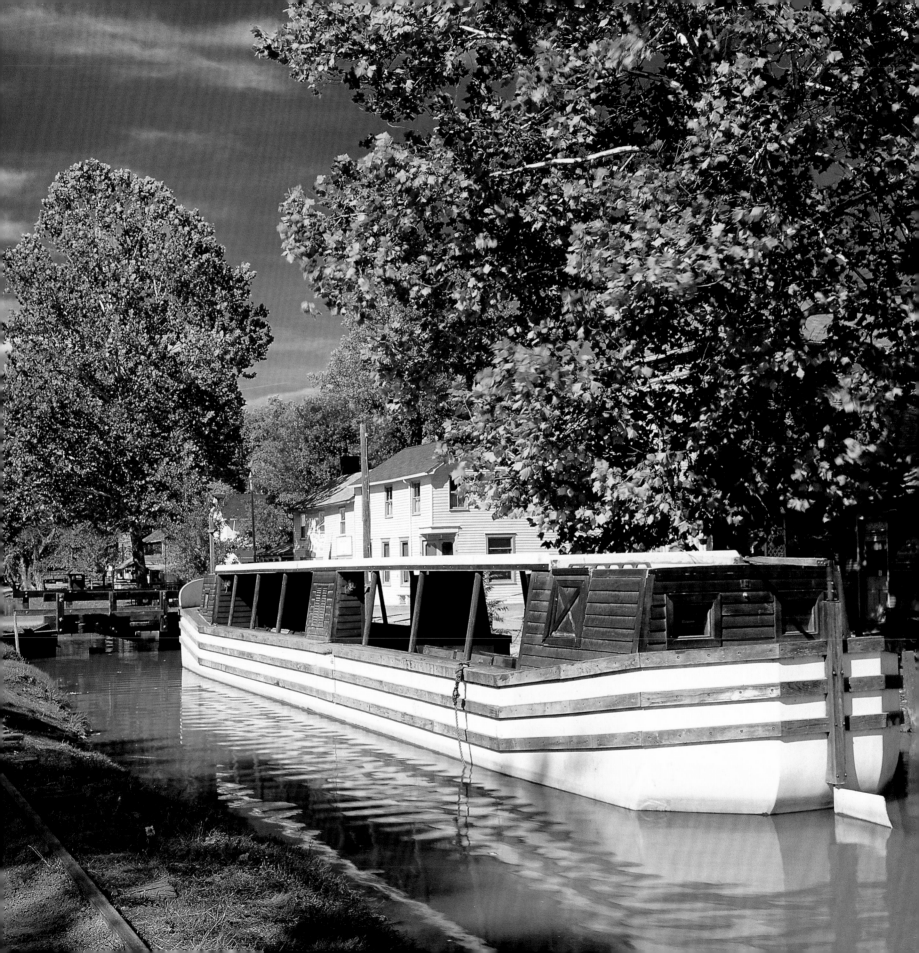

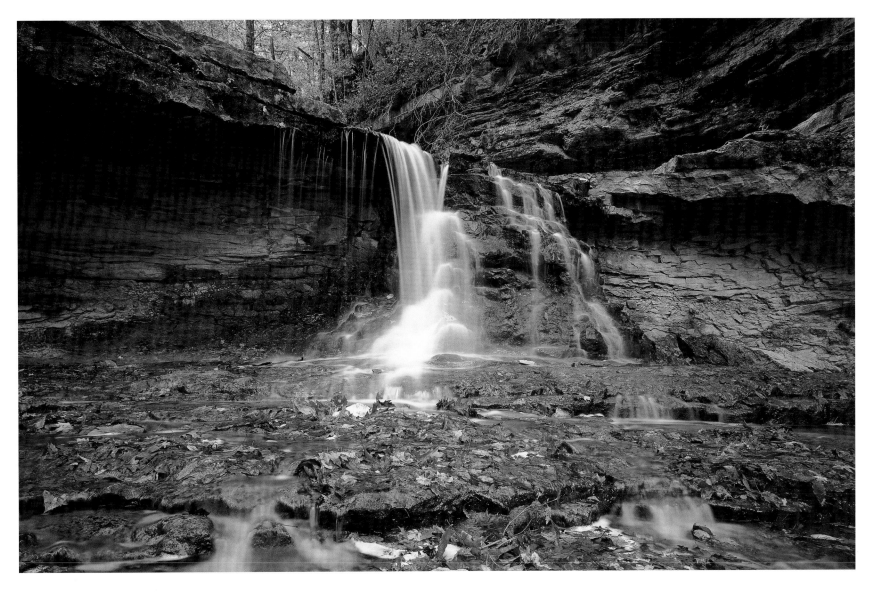

Established in 1916, McCormick's Creek State Park was the first state preserve in Indiana. It was named for the area's first homesteader, John McCormick. Hiking, picnicking, camping, swimming, and sports facilities make this a favorite summer destination for Indiana families.

Quiet bed and breakfasts, horse-drawn carriages, and a historic railway await visitors in Metamora, a 1930s canal town. The community's unique shops offer antiques, crafts, and collectibles.

After T. C. Steele and Adolph Shulz settled in Brown County in the early 1900s, Nashville slowly attracted more American artists. By 1926, the town of 300 boasted its own art gallery. Today, historic homes, shops, and galleries cater to travelers from around the world.

Built in 1876 and restored in 1995, the bridge in Cataract Falls State Park is a reminder of a time when more than 400 covered bridges linked the state's roadways. Slippery bridge decks proved treacherous for the horse-drawn carriages of the day—these sheltered spans were the solution.

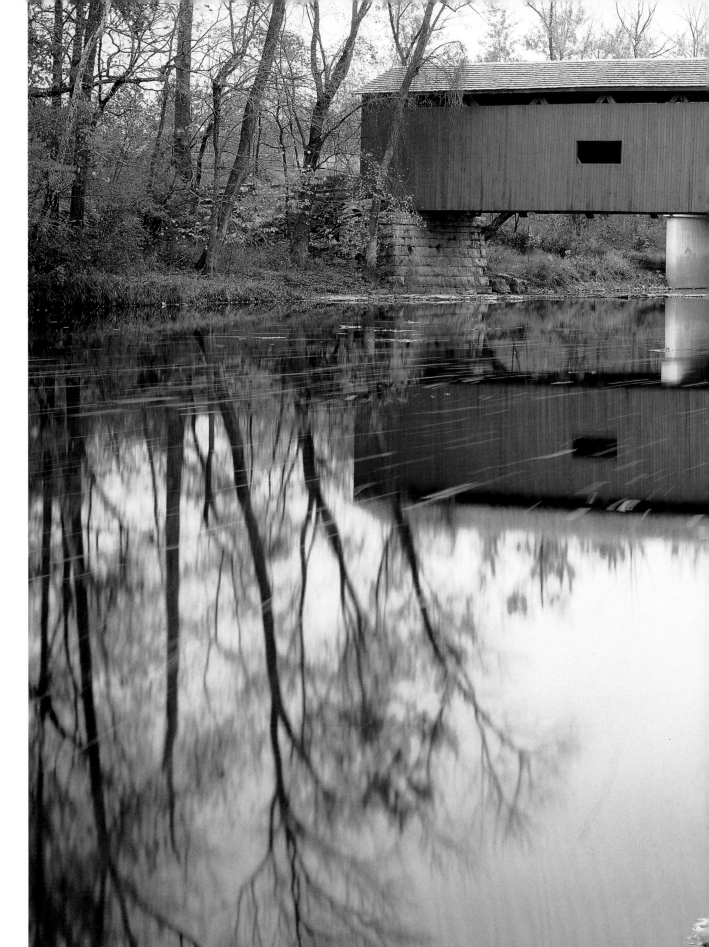

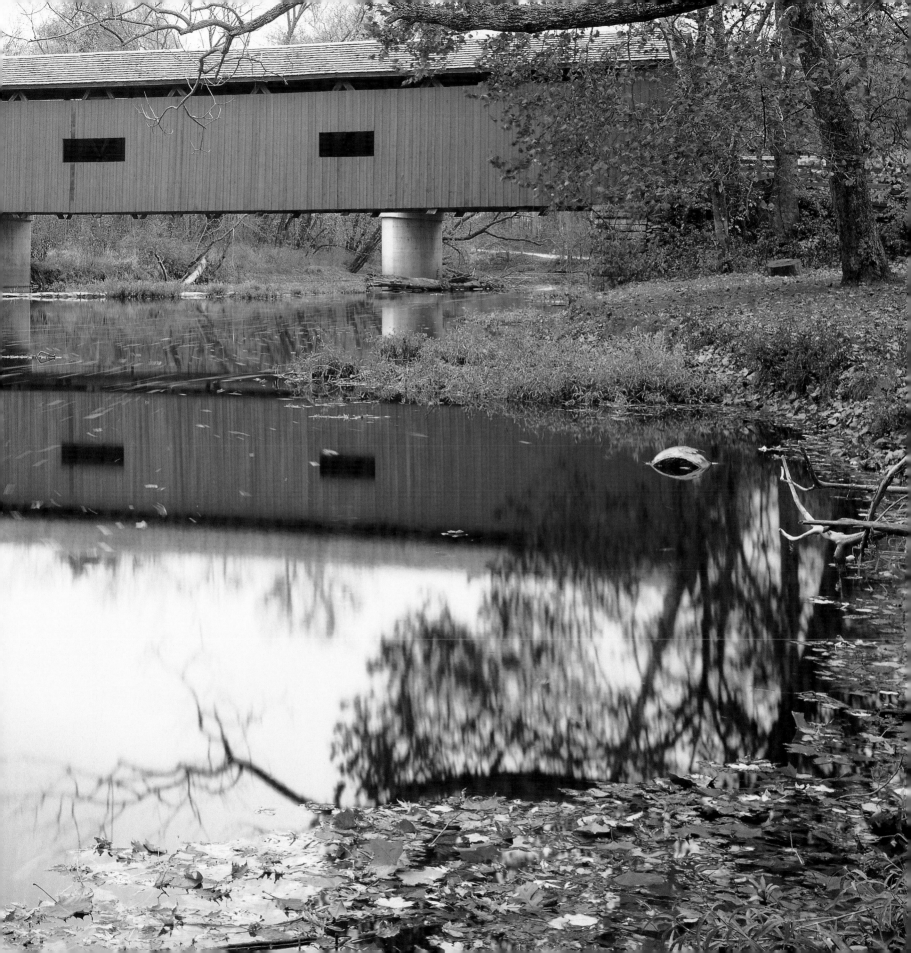

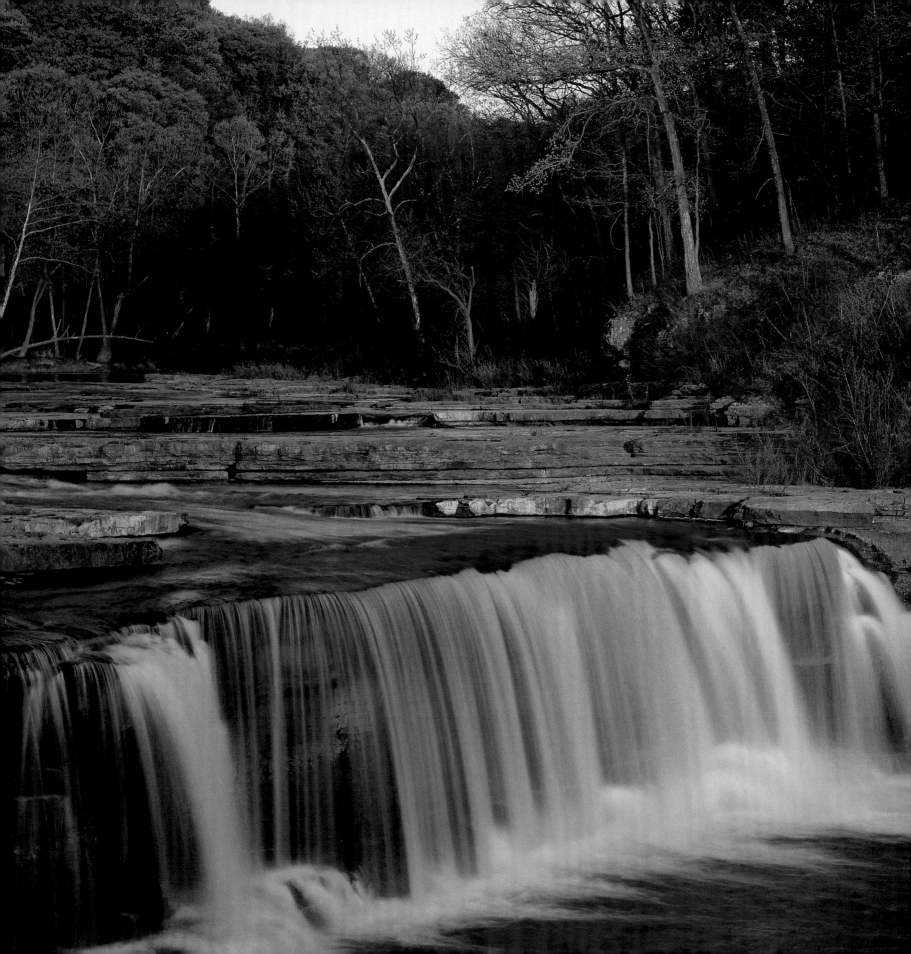

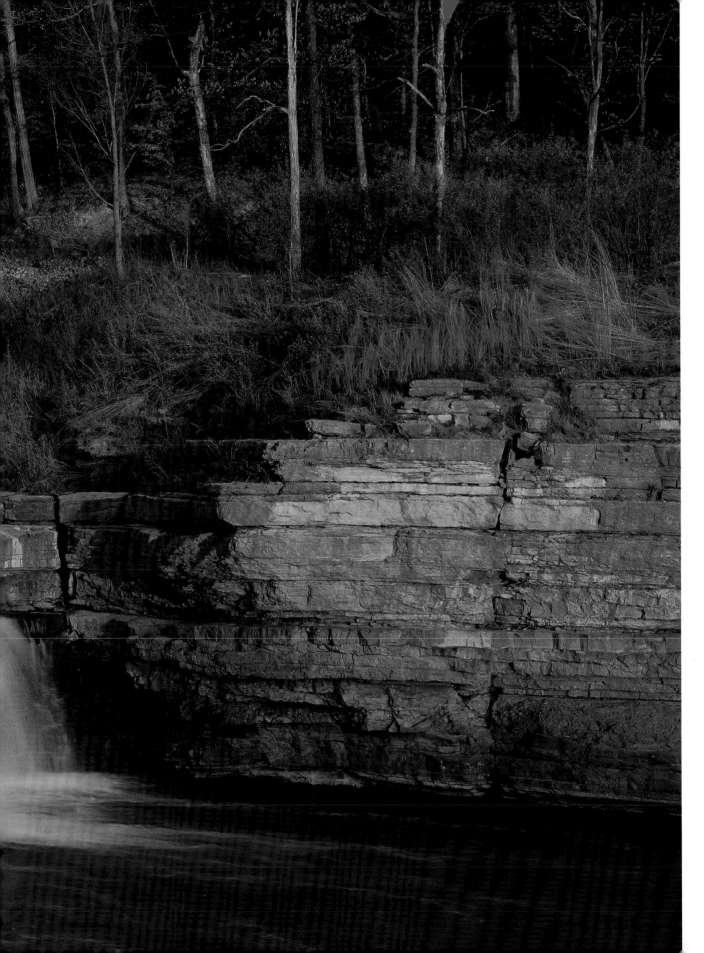

In Cataract Falls State Park, gentle Mill Creek suddenly cascades over a series of rock faces on its route toward Cataract Lake. Adjoining Leiber State Recreation Area offers facilities for camping, swimming, boating, and angling.

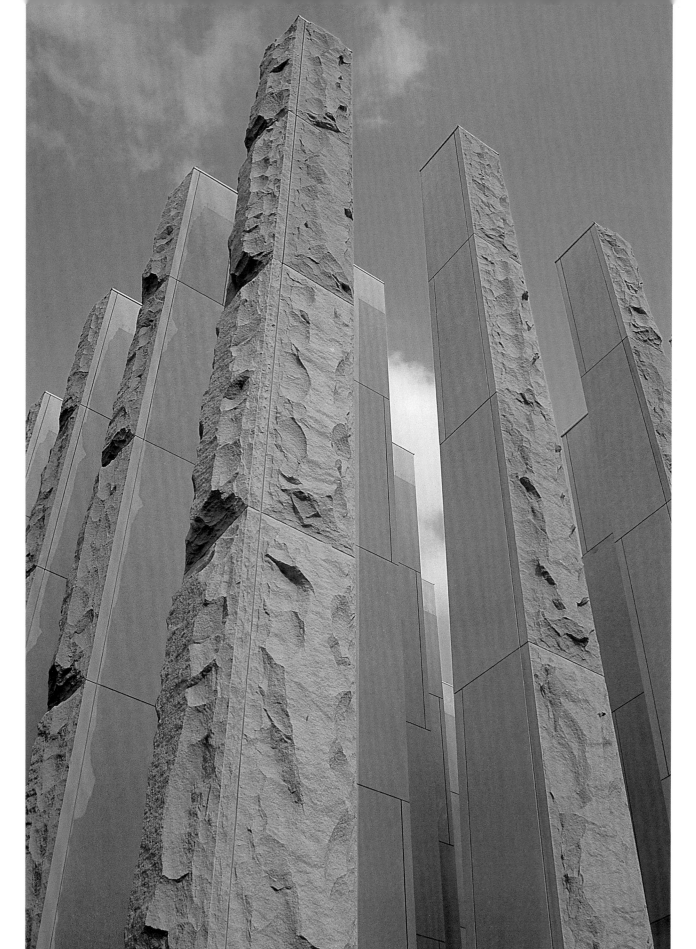

The bases of these 40-foot limestone columns in Columbus are inscribed with the names of 170 men and 1 woman who fought and died in the wars of the twentieth century. The Bartholomew County Veterans Memorial, designed by Mary Ann Thompson and Charles Rose, was built in 1997.

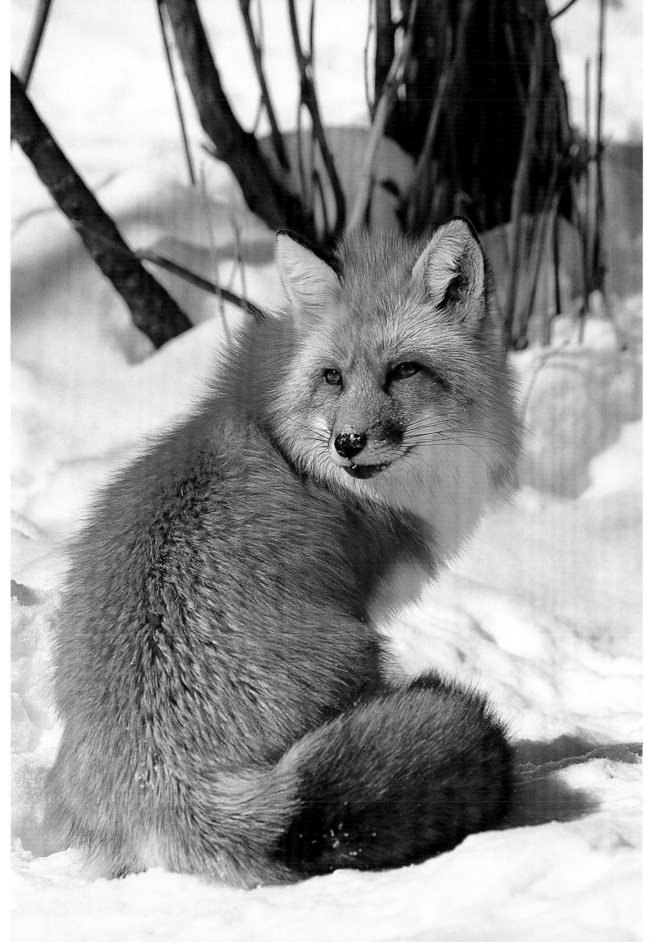

With its pointed nose and sharp ears, the red fox appears constantly alert. Common throughout the state, foxes prefer open fields and meadows, and can sometimes be seen skirting the edges of pastureland. They feed on mice, squirrels, rabbits, birds' eggs, and even fish, when they can catch them close to shore.

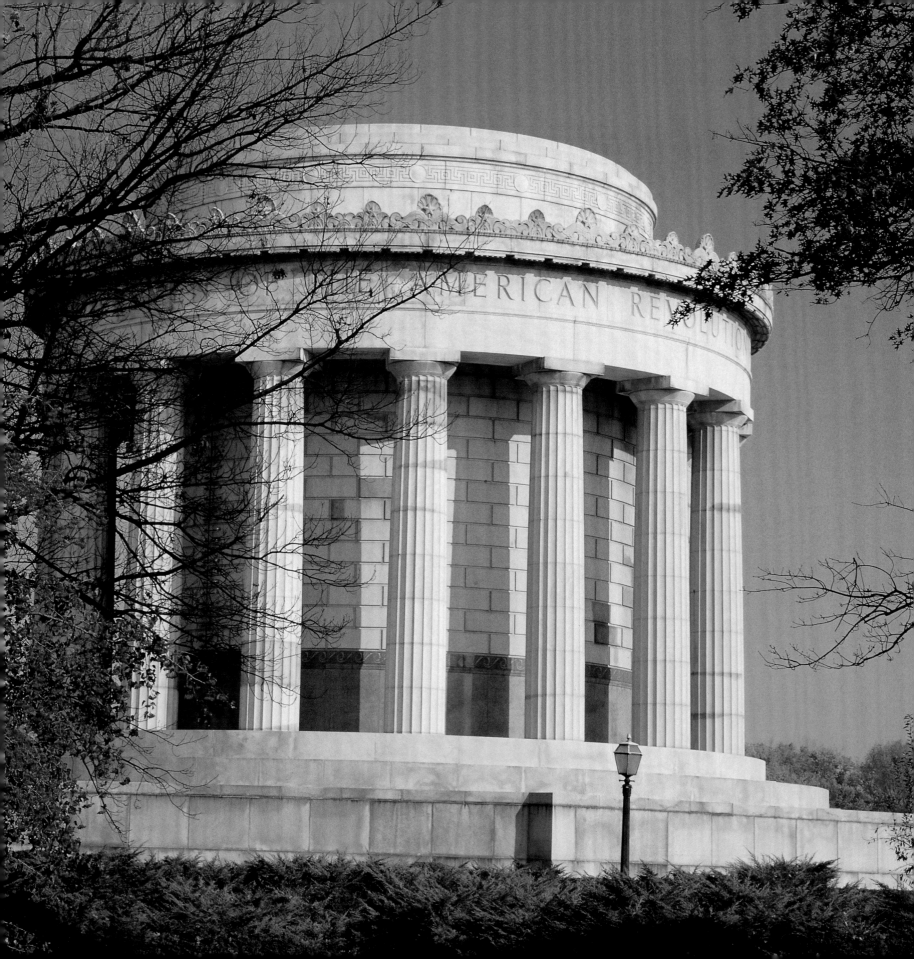

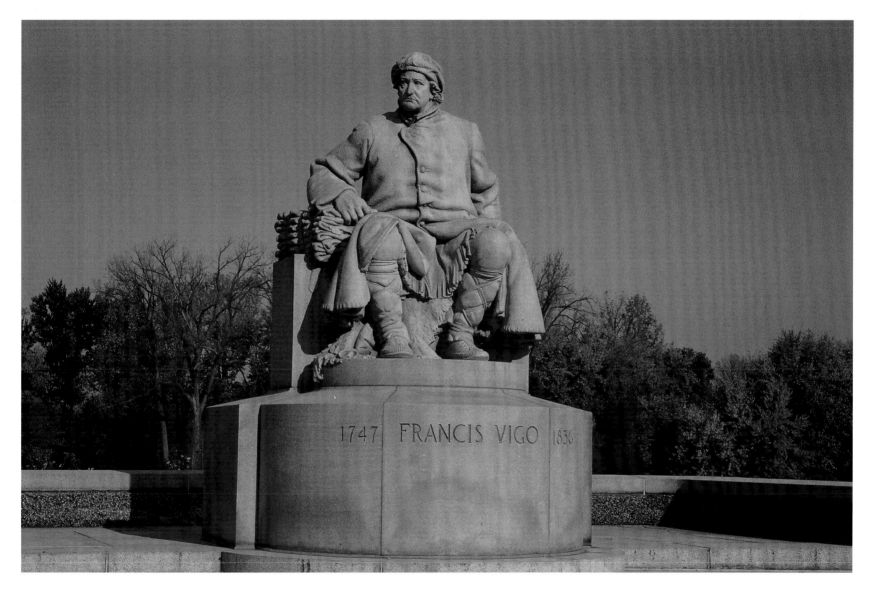

1747 FRANCIS VIGO 1836

Merchant Francis Vigo was captured by the British forces near Fort Sackville. He was released on the condition that he did not act against the British as he travelled back to St. Louis. Vigo agreed, returned to St. Louis, then set off in search of American forces. His information about the British military was instrumental to the plans of George Rogers Clark.

This stately memorial in George Rogers Clark National Historic Park stands on the site of Fort Sackville, where frontiersmen, under the leadership of George Rogers Clark, held the British forces under siege and eventually obtained their surrender.

New Harmony was founded almost two centuries ago by the Harmonie Society, a group of German settlers attempting to build a utopian society. In the mid-1800s, scientists and academics arrived, also seeking an ideal life. Today, visitors find historic buildings, artists' workshops, and a sense of tranquility that has survived since the town's inception.

Standing within the Lincoln Boyhood National Memorial, this bronzed fireplace is all that remains of the cabin where Abraham Lincoln spent 14 years of his youth. His mother, Nancy Hanks Lincoln, is buried nearby.

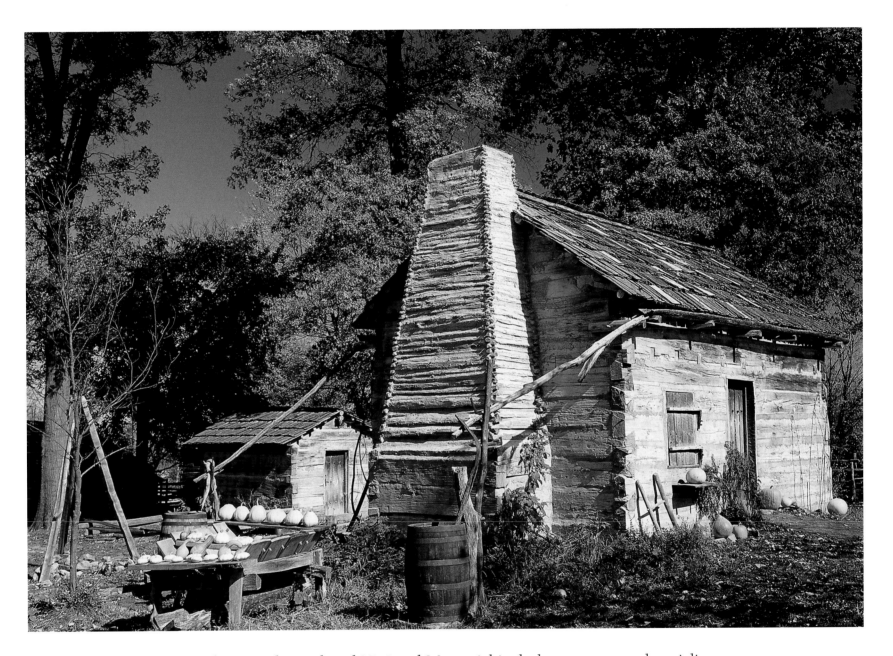

The Lincoln Boyhood National Memorial includes a museum chronicling the president's youth, more than 1,000 photos of Lincoln, and a Living History Farm. The farm allows sightseers to see the homestead in operation, as costumed "pioneers" split rails, spin wool, make shingles, or cook.

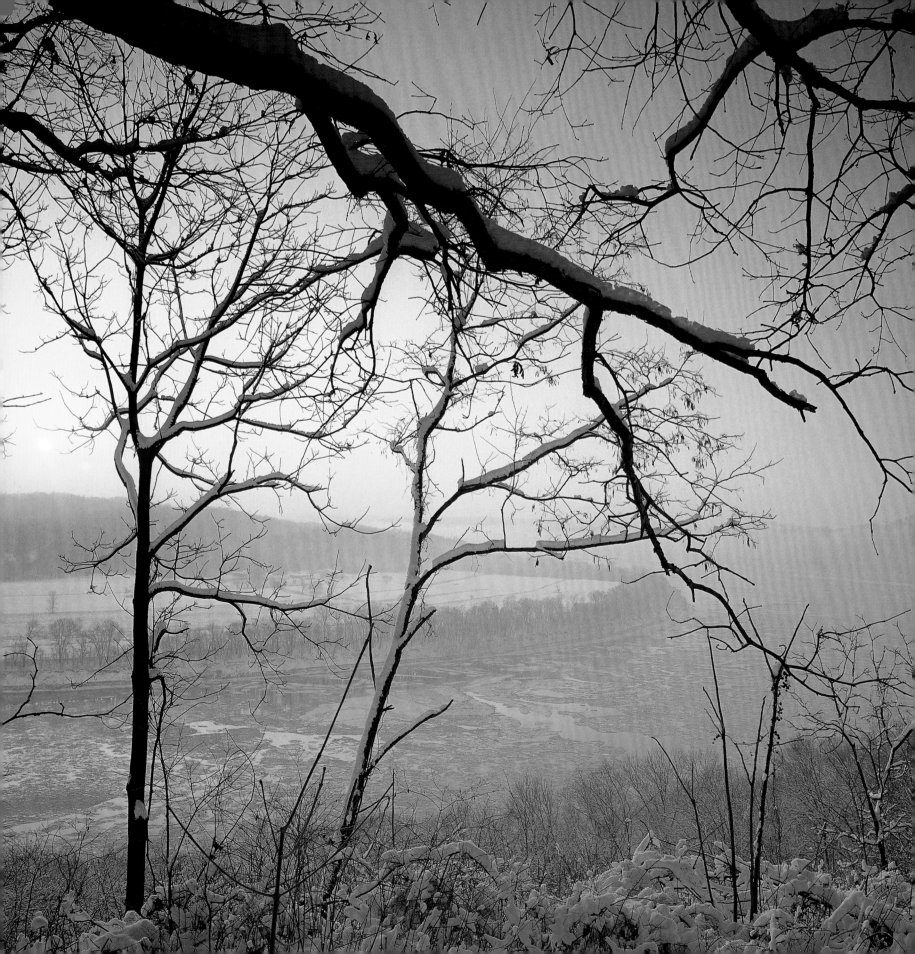

In the late 1800s, more than 1,000 sawmills processed Indiana's hardwoods. The land that is now Hoosier National Forest was logged between 1870 and 1910. Once it was cleared, it was sold to homesteaders for as low as a dollar per acre. Today the trees have reclaimed the region, and the forest is again home to such wildlife as white-tailed deer and endangered bat species.

FACING PAGE—
Flowing toward the Mississippi, the calm, wide waters of the Ohio River form the southern border of Indiana. Meriwether Lewis and William Clark navigated this waterway as they set off on their transcontinental explorations in 1803.

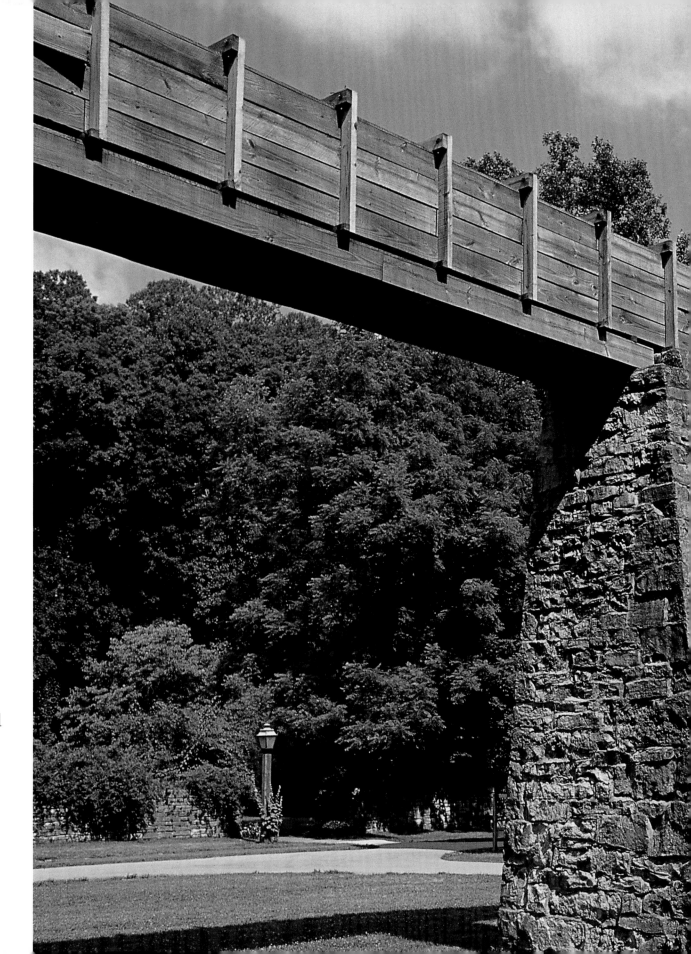

Spring Mill State Park has both historic and natural attractions. A pioneer village and grist mill remind tourists of the eighteenth-century settlers who once farmed the surrounding land. Nearby are hiking trails, caves to be explored, tranquil fishing spots, and more.

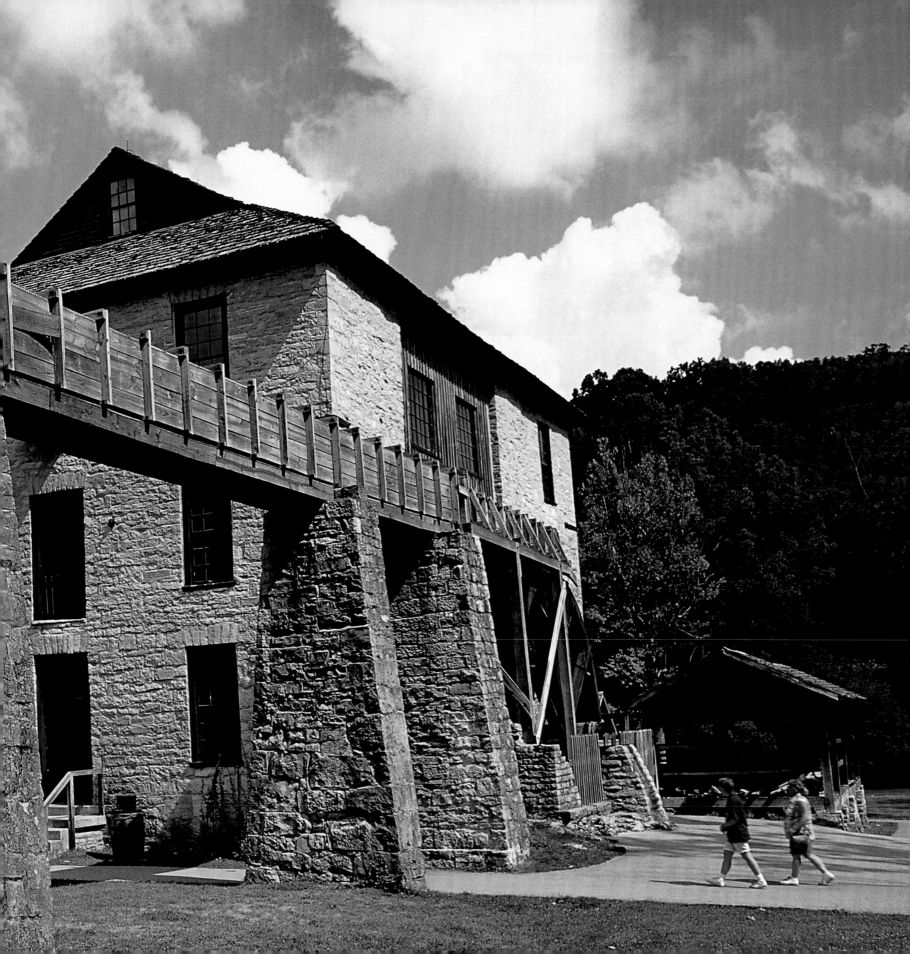

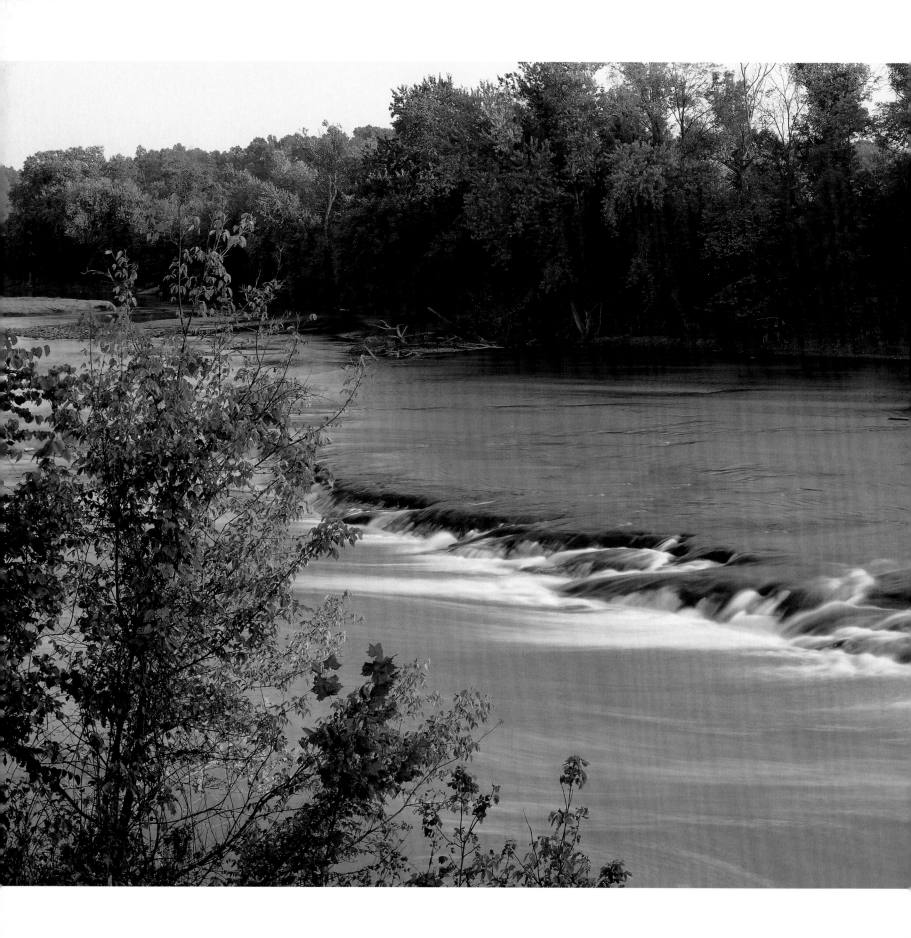

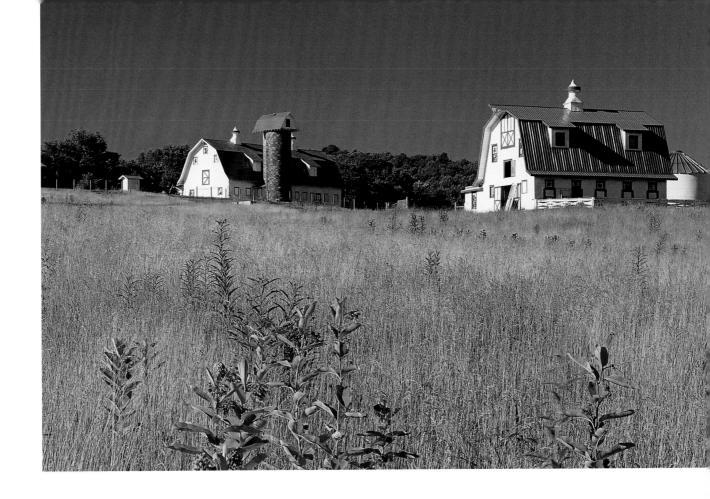

The abundant water and fertile valleys of Orange County enticed homesteaders as early as 1807. Visitors are now just as important to the Orange County economy as agriculture, but the area still harvests 22,000 acres of corn and 17,500 acres of soybeans each year.

In Columbus, the East Fork separates from the White River and winds along for 200 miles before joining the West Fork near Petersburg. Broken by sandbars and waterfalls, frequented by wildlife, and bordered by lush trees, this is one of the state's most popular paddling routes.

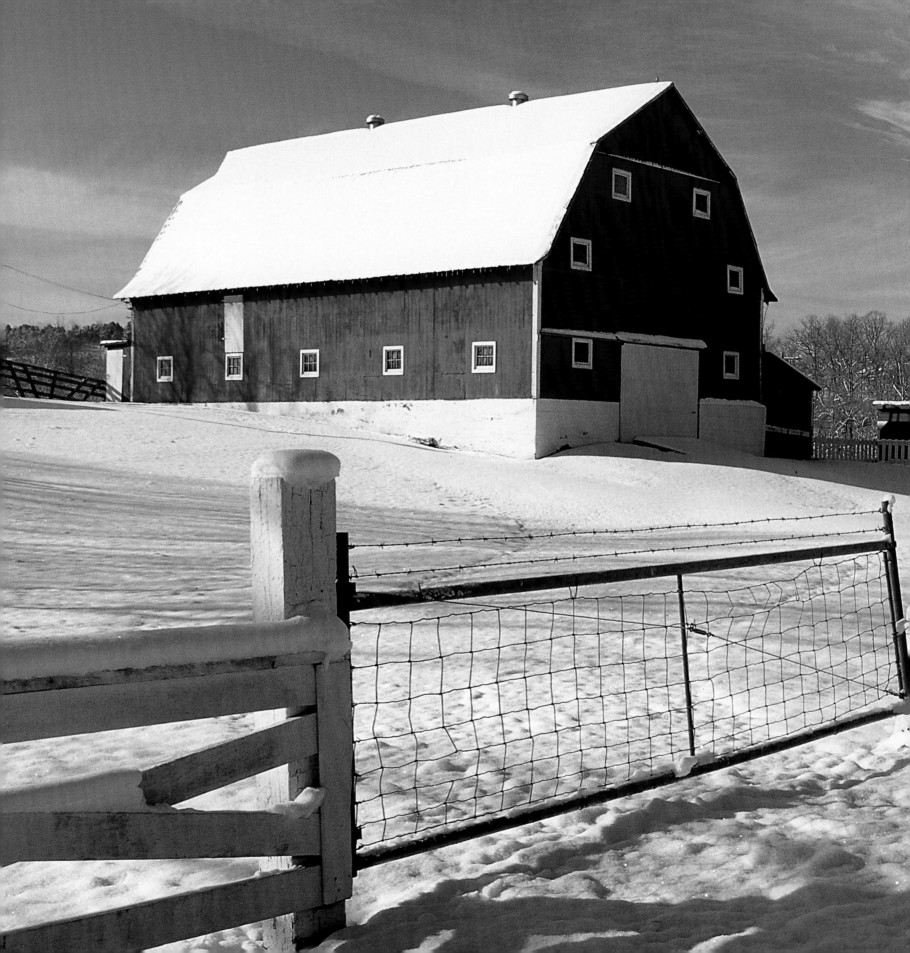

Farmers were slow to settle the land of Indiana, though the region's native people had been growing corn, squash, and beans here for centuries. In 1800, the newly established Indiana Territory included present-day Indiana, Michigan, Wisconsin, Illinois, and some of Minnesota, and was home to only 5,600 settlers.

OVERLEAF—
Harrison-Crawford State Forest lies along the Ohio River in the southernmost part of Indiana. Established in 1932, the forest now envelops more than 24,000 acres and is carefully managed to provide timber as well as many recreational opportunities.

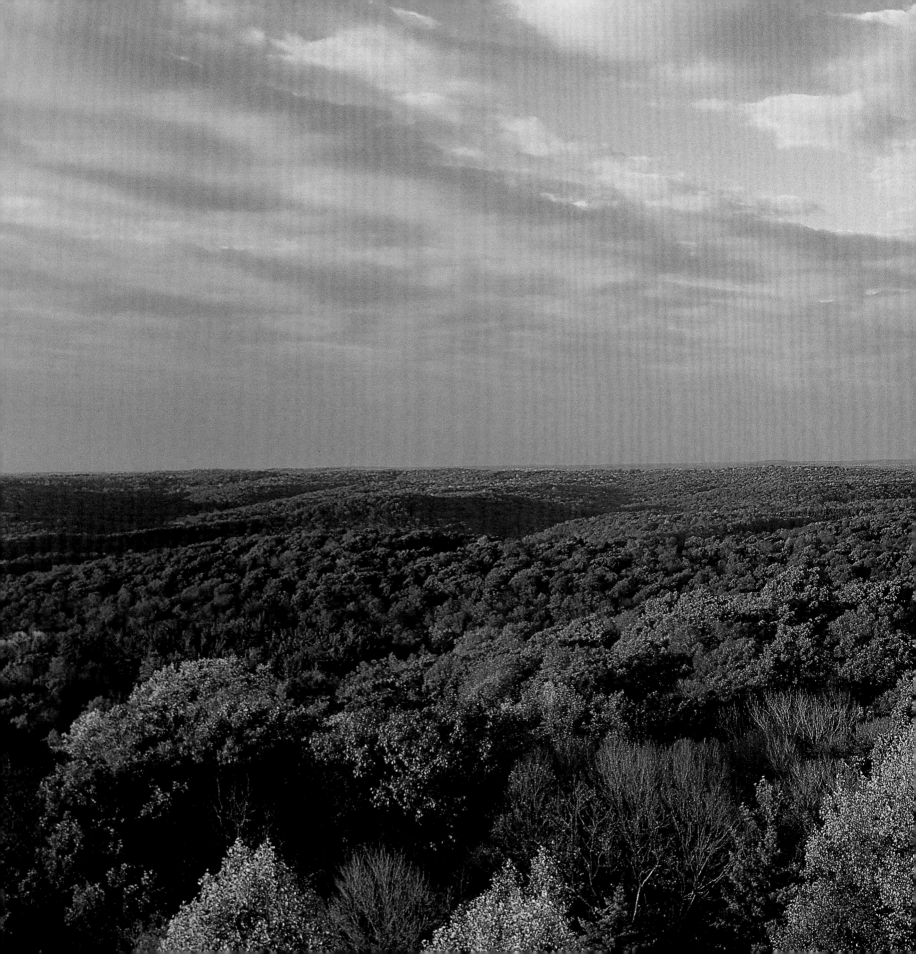

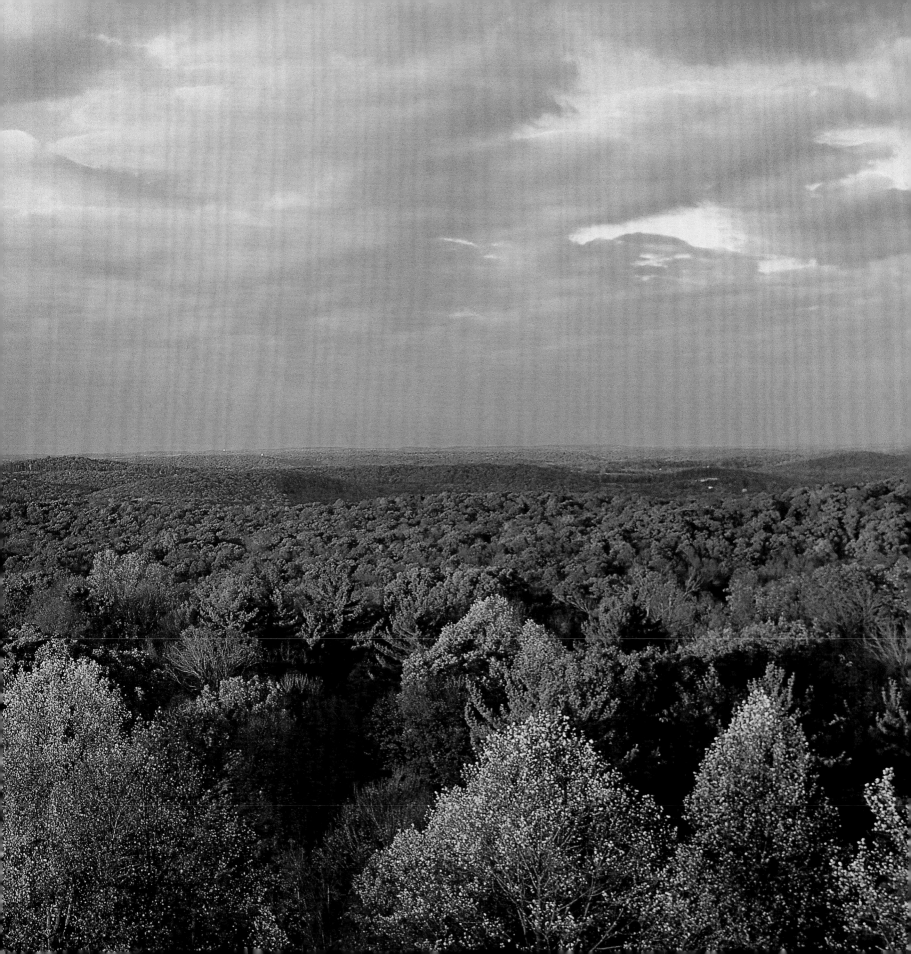

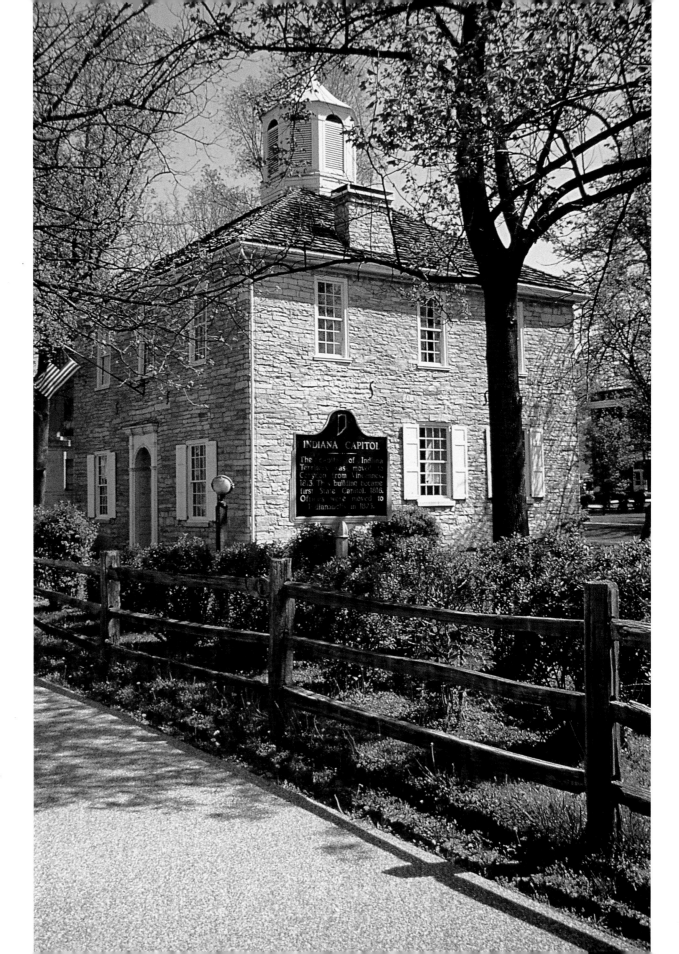

From 1813 until 1825, the tiny hamlet of Corydon served as Indiana's capital. Originally intended to be a courthouse, this building was already under construction when the government arrived in town. The renamed capitol building was completed in 1816. At the end of that year, Indiana officially became the nineteenth state.

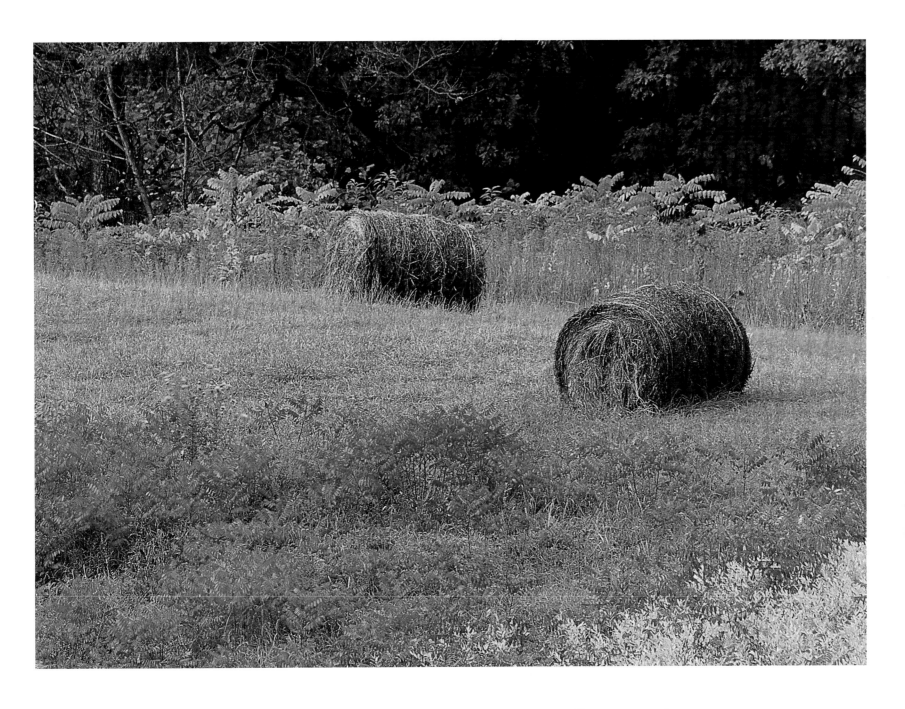

There are 63,000 farms in Indiana, encompassing 15.4 million acres. The state ranks fourth in America in corn production and third in soybean production. Many livestock farms, such as this one in Harrison County, grow feed crops such as hay and corn—Indiana ranks fifth for both hog and chicken production.

Squire Boone, Daniel's less famous brother, was a prominent Indiana pioneer and a soldier in the Revolutionary War. In 1790, he discovered a series of caves (now open to the public as Squire Boone Caverns) and moved his family to the area. The grist mill he built nearby uses an 18-foot waterwheel to turn 1,000-pound grinding stones. It still grinds corn today.

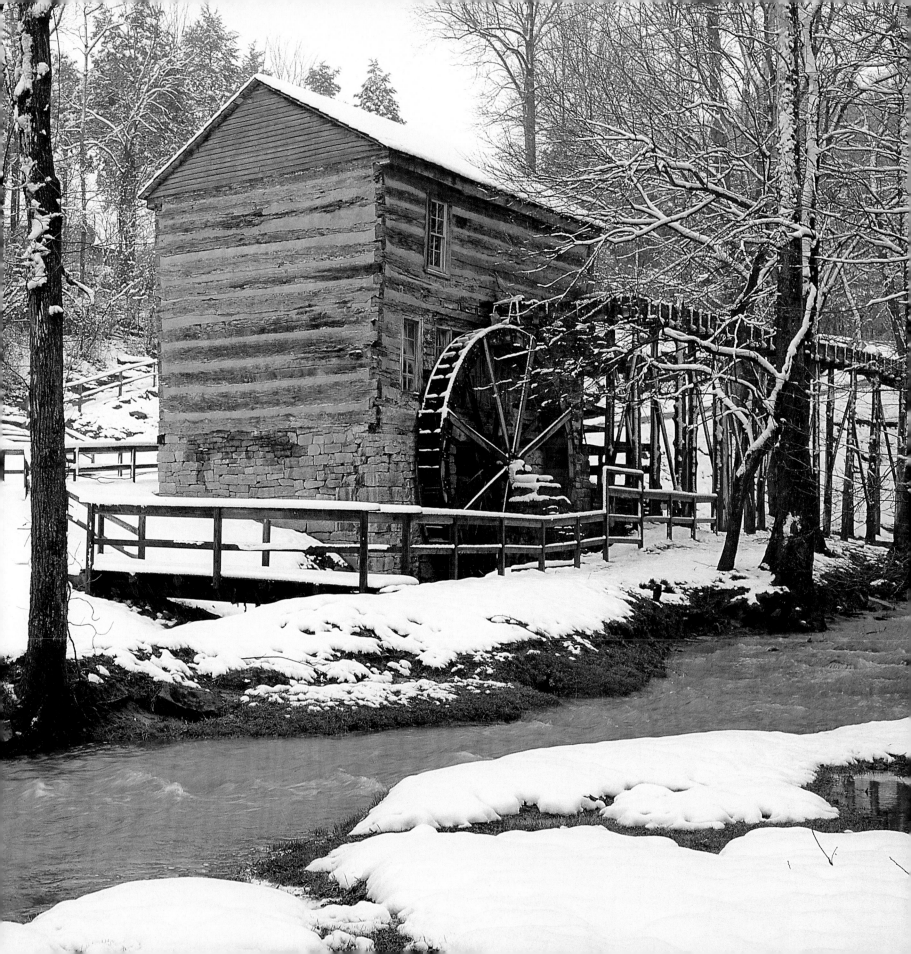

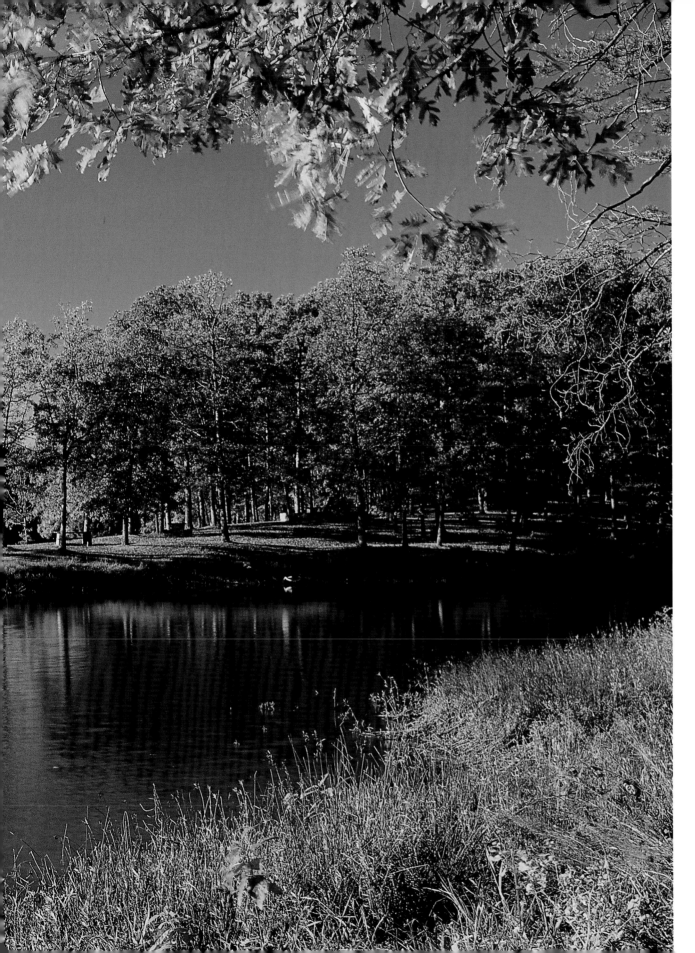

Established in 1903, Clark State Forest was the first in Indiana and served for many years as a site for experimentation and innovation in forestry methods. Stands planted between 1905 and 1935 as part of these experiments still flourish today. The forest also offers fishing lakes, campsites, and hiking and bridle trails.

The interpretive center in Falls of the Ohio State Park offers a gateway to the 400-million-year geological history of the region. Flooded in the winter and exposed each summer, the fossil beds in the river below have revealed more than 600 species from a time when Indiana and Kentucky were the floor of a tropical sea.

FACING PAGE—
The Culbertson Mansion, part of New Albany's historic Mansion Row, was once home to the wealthiest man in Indiana. William Stewart Culbertson was a railway and banking baron who built this house for his family in the mid-1800s. His wife, Cornelia, then funded a similar mansion and opened it as a home for widowed women.

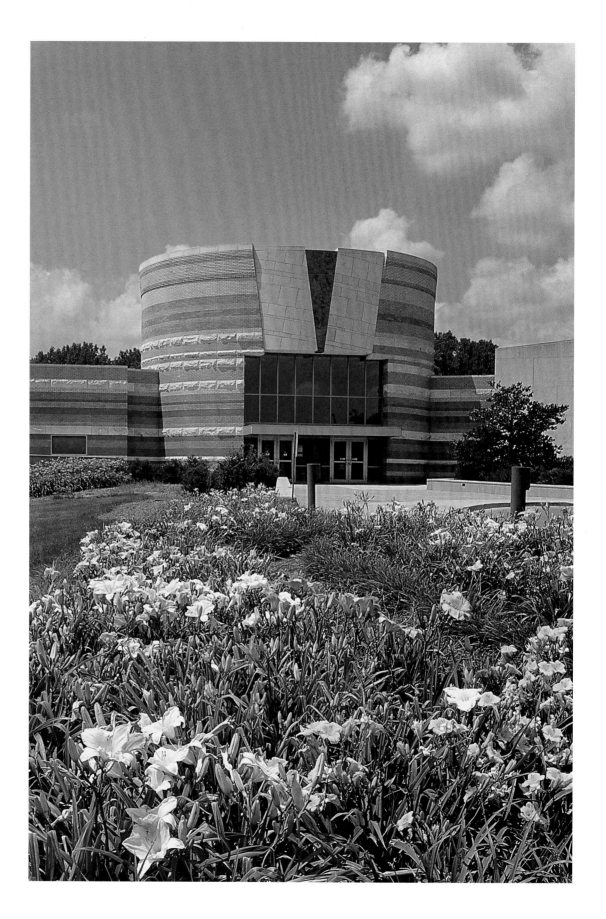

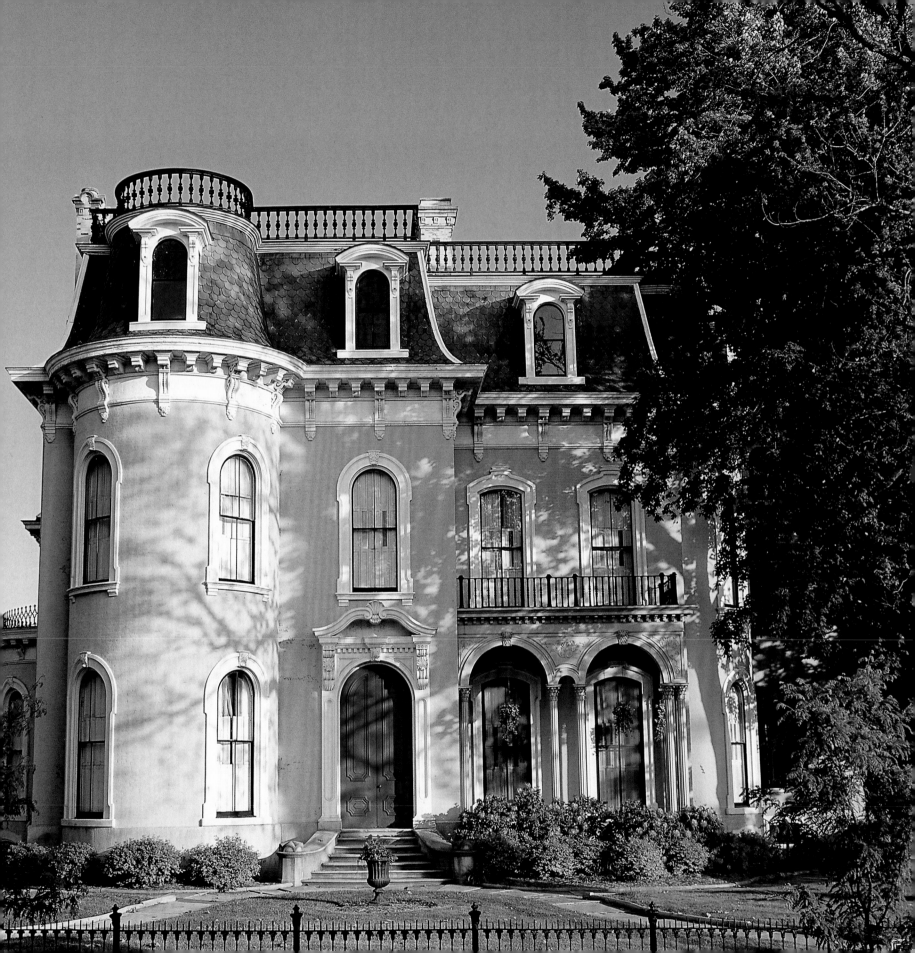

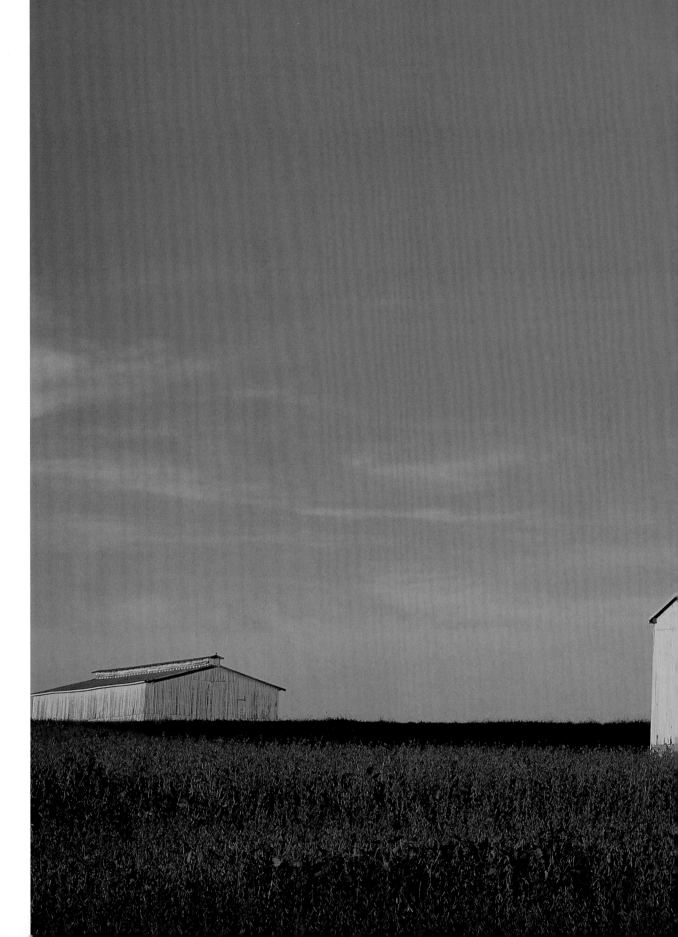

Jefferson County lies in southeastern Indiana, within a triangle formed by Indianapolis, Louisville, and Cincinnati. Between these expanding cities, the county has maintained its rural charm, offering visitors a combination of pastoral views and historic sites. The National Trust for Historic Preservation has named Madison, the county seat, one of 12 distinctive destinations in the nation.

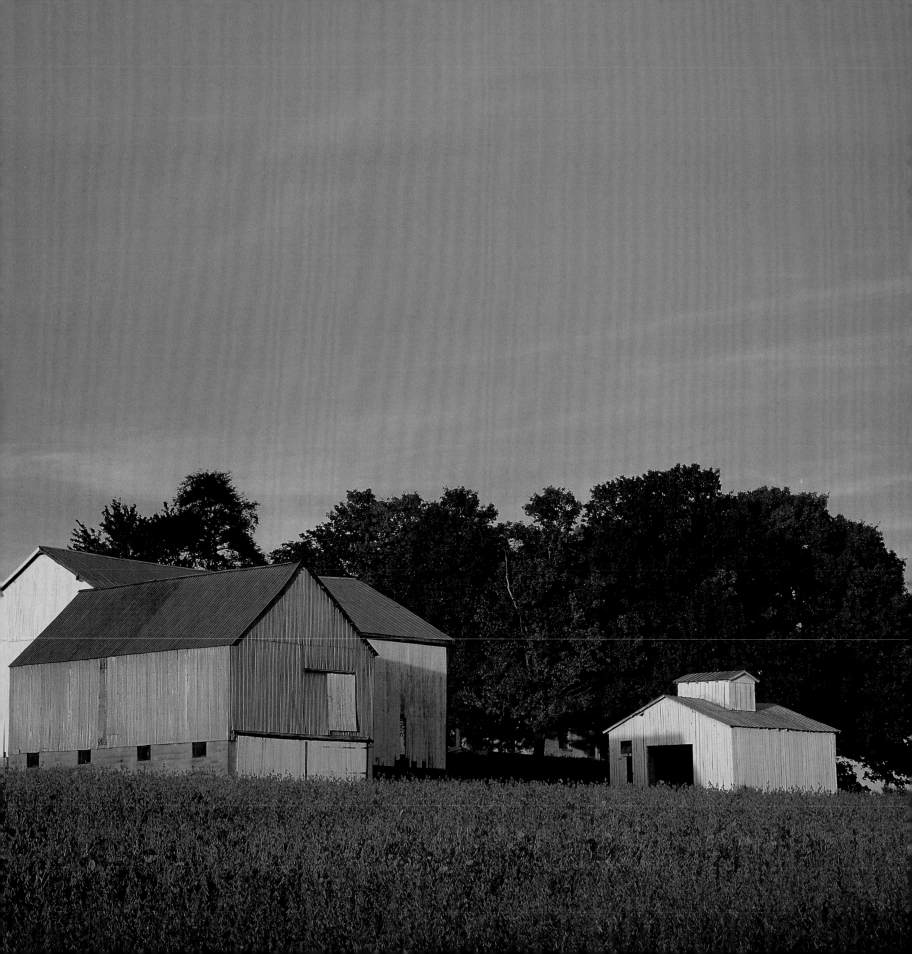

Though it appears tranquil, the Ohio River contributed to one of the greatest natural disasters in Indiana's history. In 1937, the river flooded much of the southern state, killing hundreds and causing immense damage.

FACING PAGE—
While some visit Clifty Falls State Park to see the waterfalls, others come to discover the fossils along the river's rocky shores. As Big Clifty Creek drops toward the Ohio River, it has exposed the creatures of the ancient Ordovician age (half a billion years ago).

OVERLEAF—
In north and central Indiana, the growing season lasts from mid-April until the frosts of late October. Winter finds farms such as this one near Georgetown blanketed in a deep layer of snow as temperatures drop and winds rise.

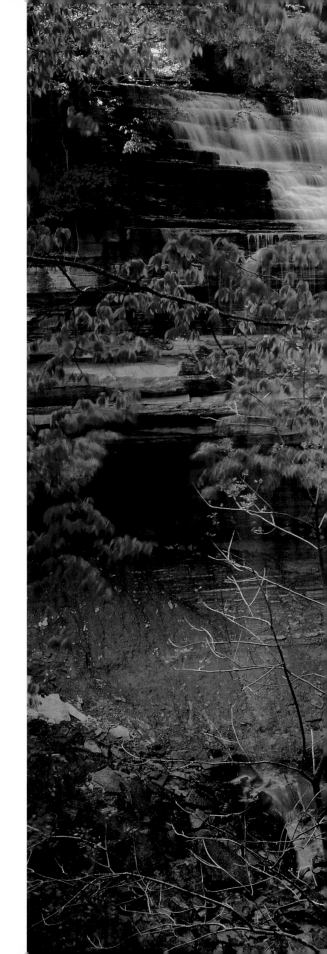

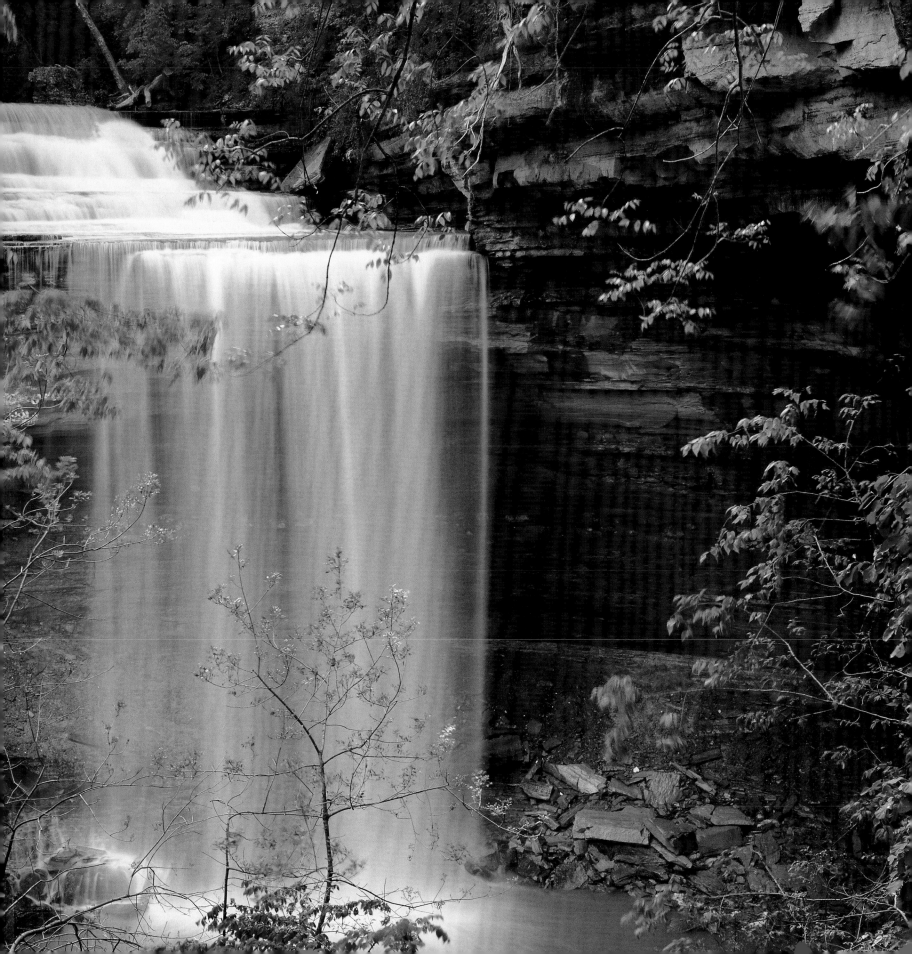

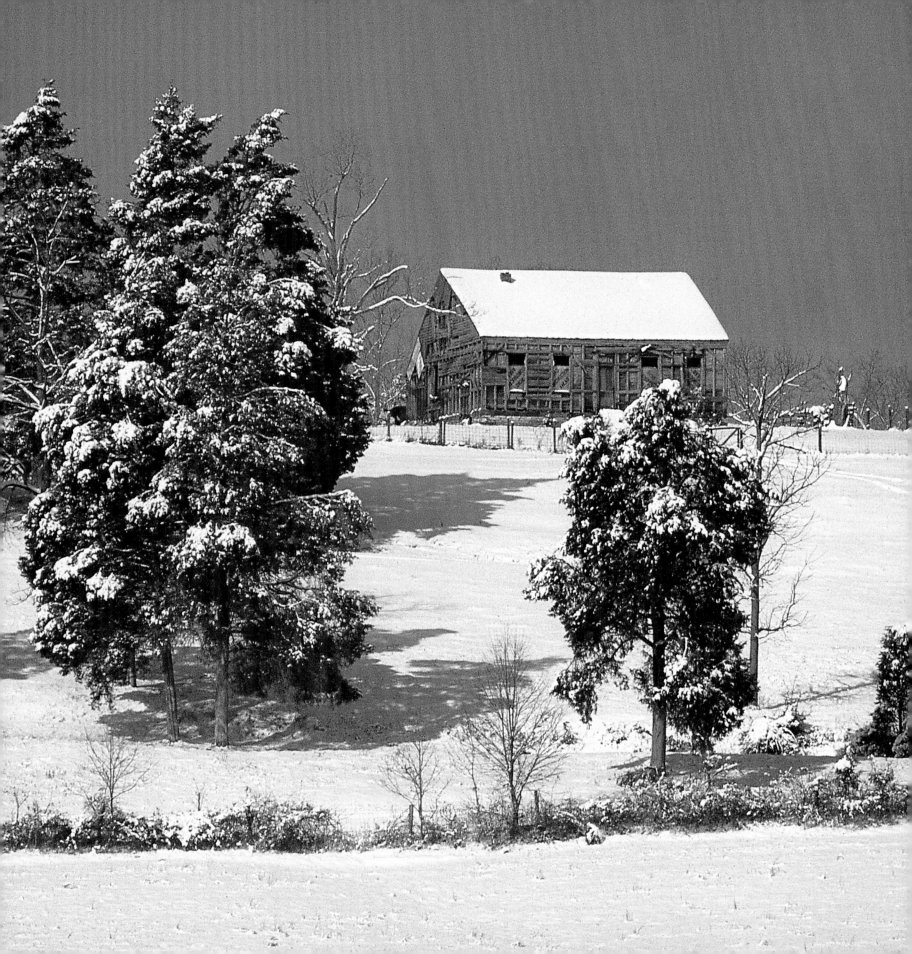

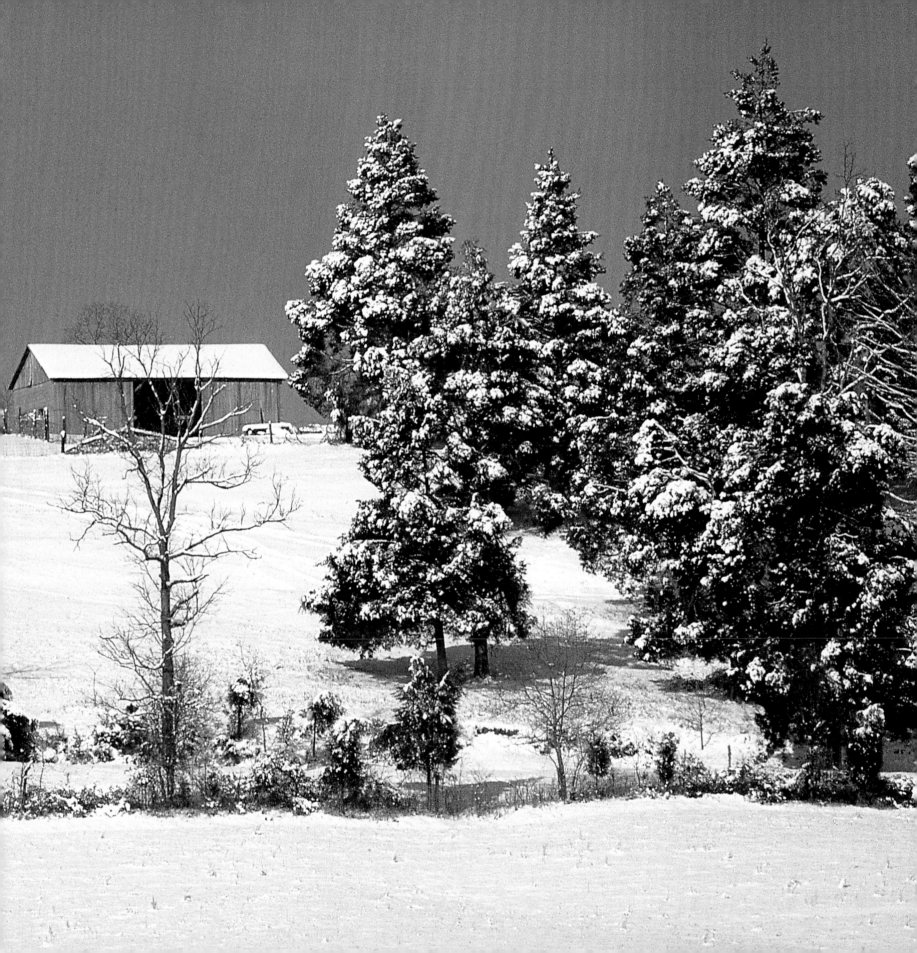